IMAGES
of America

NEW MILFORD
REVISITED

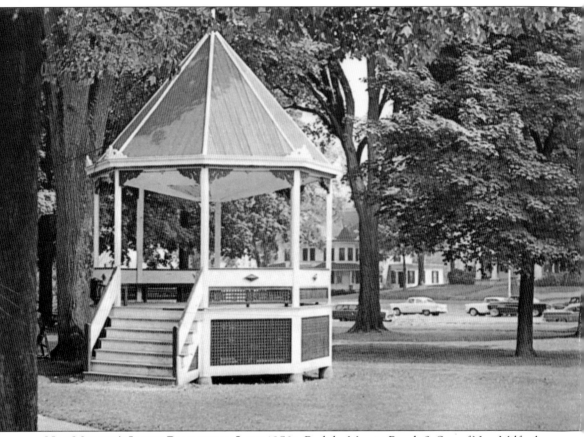

New Milford's Iconic Bandstand, Late 1950s. Built by Merritt Beach & Son of New Milford in 1891, the bandstand on the New Milford Green has seen a significant amount of wear and tear and repair over the years. It has hosted concerts, stored paper for a Boy Scout drive in the 1940s, starred in a Double Mint Gum commercial, served as a rest area for the weary, and graced the cover of *The Saturday Evening Post* in 1953. (Courtesy of the New Milford Historical Society.)

On the Cover: Seen in 1926, the C.M. Beach Company building at 30 Bridge Street was erected in 1873 by Merritt Beach. Before the Roger Sherman Memorial Town Hall existed, the third floor of the Beach building was used to conduct town meetings. The C.M. Beach Company is the oldest business in New Milford. (Courtesy of the New Milford Historical Society.)

IMAGES
of America

NEW MILFORD
REVISITED

New Milford Historical Society

ARCADIA
PUBLISHING

Published by Arcadia Publishing
Charleston, South Carolina

Printed in the United States of America

Library of Congress Control Number: 2014958701

For all general information, please contact Arcadia Publishing:
Telephone 843-853-2070
Fax 843-853-0044
E-mail sales@arcadiapublishing.com
For customer service and orders:
Toll-Free 1-888-313-2665

Visit us on the Internet at www.arcadiapublishing.com

To Leon T. Beaty, for his infinite wisdom

CONTENTS

ACKNOWLEDGMENTS

Thanks goes to the New Milford Historical Society & Museum Board of Trustees: Cheryl Bakewell, Charlie Barlow, Carolyn Critelli, Pat Hembrook, Ted Hine, Kathy Kelly Koch, Loretta Kretchko, Justin Krul, Pat Lathrope, Ron Lathrope, Hilary McKenna, Nettie McKenna, Anita Regan, and Marla Scribner. Without the board and the cooperation of the society's curator, Lisa Roush, this publication would not be possible.

Many photographers have provided the New Milford Historical Society with documentation of the town's history. Photographs in the society's collection are from the Chipman, Fuller, S.C. Landon, Simpson, and Walklet studios. Also made available for this production were pictures by and from Irma Ambler, J.E. Canfield, Russell V. Carlson, Joe Cats, Clarence H. Evans, Burton Green, H.D. Hine, Harold I. Hunt, Kathy Maher, Hilary McKenna, Frank P. Meloy, J.H. Nettleton, Howard Peck, B.W. Street, and Jim Williams.

Information was provided by those responsible for previous publications sponsored by the historical society: Charlie Barlow, Rachel D. Carley, James Dibble, and Howard Peck. Also, resources by Samuel Orcutt, Francis L. Smith, the New Milford Trust for Historic Preservation, and the *New Milford Times* were utilized.

Special consideration is given to Malcolm Hunt, past president of the historical society, whose research of records of people and places, and the organization of that information, has been invaluable. Also, the research and writing of team Waldrop (Legard and Hank) cannot be equaled, and they provided numerous facts. Additionally, those who attached names, dates, and other information to photographs are to be thanked; they will probably never know the importance of their endeavors. A special thanks goes to Bob Coppola for his never-ending support.

Finally, two board members of the society were especially helpful. Hilary McKenna obtained photographs and provided her expertise in written composition. With her impeccable research skills and knack for creative writing, Kathy Kelly Koch provided text and resources that no one else could imagine, and she was always ready to work.

Unless otherwise noted, all images appear courtesy of the New Milford Historical Society & Museum.

Kathleen Zuris
Assistant Curator
The New Milford Historical Society

INTRODUCTION

New Milford holds the distinction of being the second-oldest town in Western Connecticut. Since 1707, when settlers made their way to the banks of the Housatonic River, it has been a vibrant and thriving community.

The early settlement of New Milford differed somewhat from that of other Connecticut towns, in that it was founded through an ambitious land-speculation business, instead of individual land purchases. In 1705, the General Assembly granted Robert Treat and 1,100 other investors the right to purchase 50,000 acres along the Housatonic River from the newly formed Milford Company.

Interest in land investment caused New Milford's population to grow, and the settlement around the current downtown green began to take shape. By 1815, the village comprised 60 houses, and the creation of the commercial district around the railroad depot was well under way. With the opening of the southern portion of the Housatonic Railroad in 1840, New Milford became an industrial and trading center for the surrounding region.

Between 1865 and 1880, a single construction company built more than 75 houses around downtown New Milford. The Village Improvement Society landscaped the green and built the iconic bandstand that is still in use today. In addition to the residential homes, this area included businesses, a public library, banks, and a town hall.

Downtown New Milford continued to expand until the disastrous fire of May 5, 1902, which almost completely leveled the commercial district. The fire started in the rear of the New Milford House's barn and quickly spread to the neighboring property of Mrs. John Murphy. The winds carried and spread the fire; the lack of proper water pressure allowed the fire to extend to the old and crowded nest of livery stables and barns behind Bank Street. Fire crews came by train from as far away as Danbury to help pump water from the Housatonic River, but their efforts were too little, too late. Among the few structures to survive were the railroad station, the United States Hotel, the Noble Brothers Button Factory, and the firm of Merritt & Beach. Were it not for the determination and collective strength of citizens, this devastation to the economy might have signaled the end of New Milford. The next morning, with buildings still smoldering, businesses began to build wooden structures on the green, referred to as "Shanty Town," and reopened their shops as if nothing had happened. Even the bandstand was pressed into service as the town's temporary barbershop. Almost immediately, the town began the monumental task of clearing the rubble and rebuilding the commercial district. After the fire, streets were improved, the water system was extended, and new buildings with stricter building codes were erected. In less than two years, no trace of the fire was visible.

In April 1906, an article in the *New Milford Gazette* called for all citizens to meet at Mygatt's Hall on Bank Street to consider the project of celebrating the town's 200th anniversary the following year. At the end of April, 40 people met to discuss the celebration and voted to set up numerous committees, ranging from refreshments to finances, and set the opening date for the four-day celebration as June 15, 1907. The decorations committee donated the first public flagpole

and flag, unveiled at the opening exercises, and festooned the entire town in flags and bunting. There were religious observances, music programs, car parades, fireworks, and receptions. It was estimated that 16,000 people attended the bicentennial event.

Charles N. Hall delivered the opening address, closing with this: "But while we celebrate New Milford, past and present, what shall we say of the New Milford to come? Shall not the civic pride and energy, and patriotism that have inspired this celebration, continue to be moving forces toward a better New Milford?" A popular feature of this celebration was the Loan Exhibit of Antiques and Historical Items, on display at Memorial Hall. In addition to the local artifacts associated directly with life in New Milford's past, there were a number of curiosities from remote corners of the world, testifying to the important role played by residents of New Milford in earlier times as merchants, shipowners, and missionaries. At the conclusion of this event, many residents expressed the desire to find a permanent place for the safekeeping and display of the artifacts and heirlooms. This idea spurred the formation of the New Milford Historical Society & Museum when a group of citizens met to formally organize the society in 1915. Many of the more than 400 objects on display were in fact donated to the society and are part of the museum's permanent collection.

In 2015, the society celebrates 100 years of continuous operation. The centennial celebration will include a recreation of the 1907 exhibit and a retrospective exhibit of New Milford history from 1915 to the present day. The publication of this book not only honors those who came before us, but is a reminder that there is an inherent responsibility on our part to leave as rich a legacy to the future generations of New Milford.

The images contained in this book are from the vast collection of photographs and postcards donated to the society over the last 100 years. These were treasured and carefully preserved by their owners and provide a glimpse into the real lives behind the images that fire our imaginations. A museum is a building that houses the antiquities and heirlooms of the past, but it really is a repository for residents' shared memories. The New Milford Historical Society Board of Trustees would like to sincerely thank Kathleen Zuris, assistant curator, for her vision, talents, and research skills, which have brought this book to fruition. We very much appreciate all of her efforts for sharing the stories and memories of New Milford with others, and we look forward to the society continuing its important role as caretaker of New Milford's proud history in the next 100 years.

Charles Beach Barlow
Board Trustee
The New Milford Historical Society

One

COME ON INN

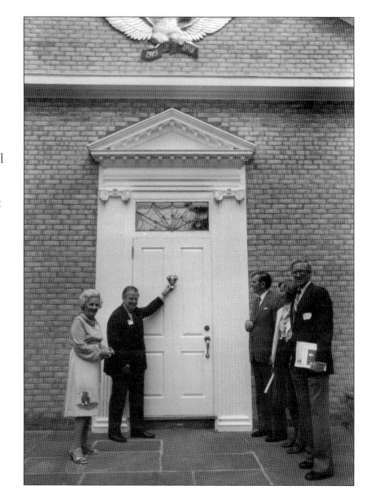

HISTORICAL SOCIETY ENTRANCE, 6 ASPETUCK AVENUE. In 1981, historical society president-elect Charles Beach Barlow welcomed the Connecticut League of Historical Societies to a meeting in New Milford. Standing at the door are, from left to right, Audrey Anderson (vice president of the league), Barlow, M. Joseph Lillis Jr. (retiring president of the society), Georgia Girardo (curator of the society), and Robert T. Sullivan (president of the league). The doorway and transom were part of the side entrance of the United States Hotel building, erected around 1796 at the corner of Bank and Main Streets.

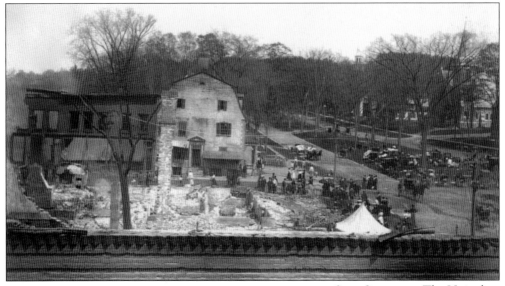

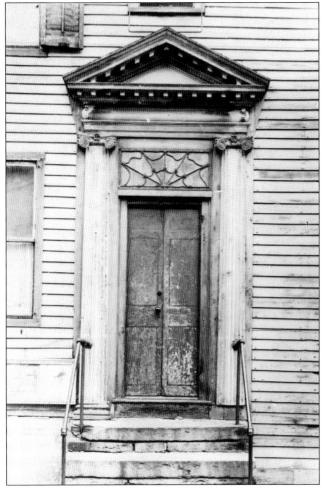

SOLE SURVIVOR. The United States Hotel, at the corner of Bank and Main Streets (2 Bank Street), stands among the ruins of the Great Fire of 1902. The view looks north from Bridge Street. The entrance to the side of the hotel on Bank Street is now the front entryway to the New Milford Historical Society & Museum.

SAVED FROM DEMOLITION. Before the building at 2 Bank Street was torn down in 1927, Albert Evitts, president of the New Milford Historical Society from 1936 to 1952, purchased the doorway. That year, it was displayed at the Metropolitan Museum of Art in New York for its fine Colonial workmanship. After the exhibition in New York, the doorway and overhead window were stored at the C.M. Beach warehouse until 1963, when they were installed as the entranceway to the newly constructed New Milford Historical Society's exhibition hall.

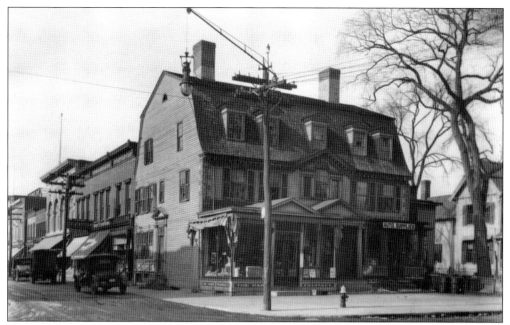

UNITED STATES HOTEL, C. 1927. Maj. Beebe Hine erected a two-story residence at this location around 1796. Later, he opened it up for lodging and added the gambrel-roofed third story and an addition to the north. The hotel was one of the largest and most complete hotels in the area. Until 1927, when it was razed, it had passed through the hands of members of two prominent New Milford families, the Mygatts and Nobles. (Photograph by Fuller Studio.)

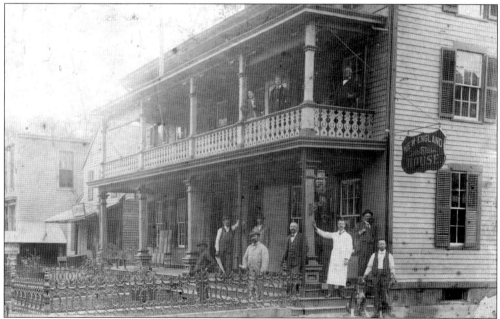

NEW ENGLAND HOUSE, C. 1895. Peering down from the second-floor balcony is the owner of the New England House, Isaac B. Bristol. The lodging house was situated at the southern corner of Main and Bank Streets, opposite the United States Hotel, but unlike its competitor, it did not survive the fire of 1902. George and Mary Pixley managed the hotel from 1896 until the fire.

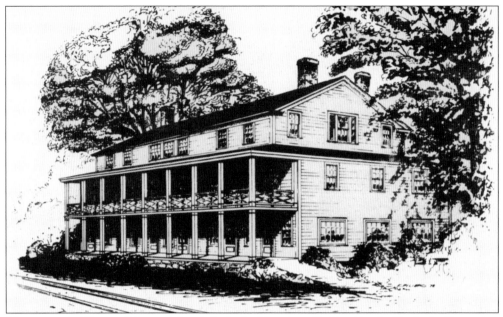

MERWINSVILLE HOTEL. Sylvanus Merwin built the Merwinsville Hotel in the Gaylordsville section of New Milford two years after the Housatonic Railroad was completed from Bridgeport to New Milford, Connecticut. The hotel opened in 1843 after the line was extended north to Massachusetts in 1842. The building contained 21 rooms and a ballroom. It was also a stagecoach stop.

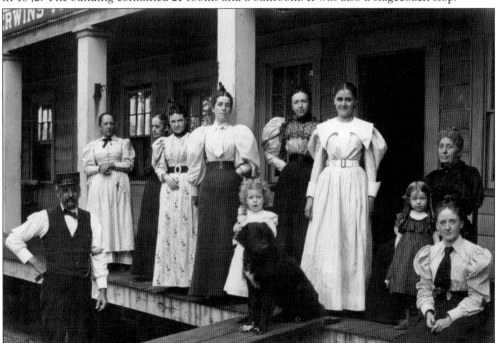

EMPLOYEES OF MERWINSVILLE STATION AND HOTEL, C. 1908. Sylvanus Merwin's daughter Helen (first woman on the left) was the Merwinsville Station dispatcher. The man to her left, Edgar Hurd, was her husband and station agent. Trains were under contract to stop here for a 20-minute meal break.

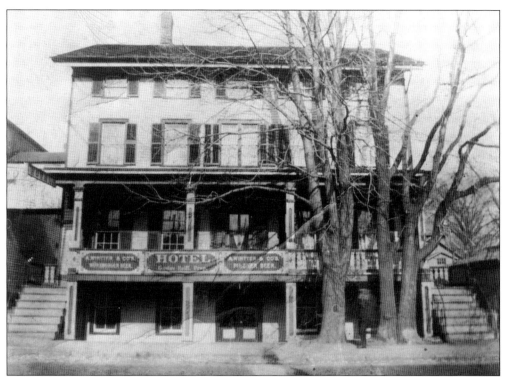

NEW MILFORD HOUSE. Another lodging place situated near a train station, the New Milford House's address was 14 Railroad Street. It was located across from the New Milford depot. Its proprietor at the dawn of the 20th century was C.M. Schreyer, and it was "always ready for transient or permanent guests." First-class livery service was provided.

YOUNG'S HOTEL. After the fire of 1902 destroyed his New Milford House, Thomas F. Young rebuilt and named the new edifice after himself. It was known as a first-class hotel with modern accommodations. When railroad passenger service ended in 1971, the hotel's business had been on the decline for a while. Young's tobacco fields are now the site of Young's Field Park.

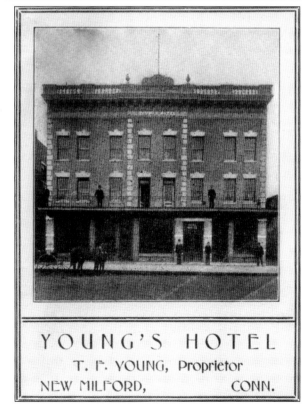

YOUNG'S HOTEL
T. F. YOUNG, Proprietor
NEW MILFORD, CONN.

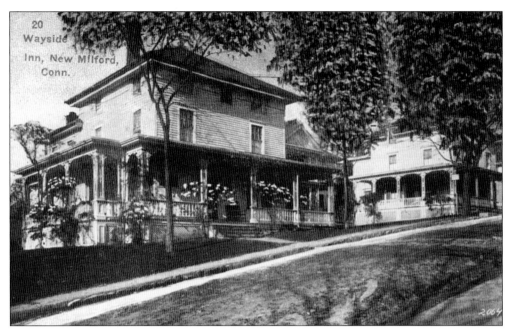

WAYSIDE INN. According to the Official Register of New Milford's bicentennial in 1907, at least 50 out-of-town celebrators stayed at the Wayside Inn on Terrace Place, close to downtown New Milford. Comprising three buildings, the complex was also a part of Sarah Sanford Black's Ingleside School.

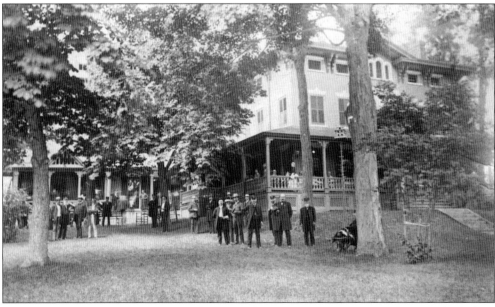

WEANTINAUG INN, C. 1900. This building at 1 Elm Street was also purchased by Sarah Black in 1902 for her boarding school for girls. It was referred to as Foundation Hall. It was built in 1812 for Sen. Perry Smith and was also the residence of John P. Treadwell.

SEASON 1890

RATES

$3.50 and $4 per day, $18 to $28 per week. Children, Infants and Nurses $10.50 to $14 per week and upwards, according to accommodations.

Intending visitors writing for rooms are kindly requested to specify particulars, time of arrival and length of stay. Parties called upon at residence if desired.

Address Proprietor " Weantinaug Inn," New Milford, Connecticut, or Mr. Uriah Welch, care Fifth Avenue Hotel, New York, where he can usually be seen on Tuesdays.

HOWARD F. WELCH, Proprietor,

" Weantinaug Inn," New Milford, Litchfield Co., Ct.

WEANTINAUG INN'S RATES, 1890. Proprietor Howard F. Welch was the son of Uriah Welch, owner of the St. Nicholas in 1878, a premier hotel on Broadway in New York built in 1853 for $1 million. New Milford's John P. Treadwell was the original proprietor of the St. Nicholas Hotel.

ST. FRANCIS XAVIER SCHOOL. In 1928, St. Francis Xavier School opened in the former Ingleside School at 1 Elm Street. The school closed in 1973, and the building is presently the home of the St. Francis Xavier Roman Catholic Church Parish Center of administrative offices, religious education, community outreach programs, and Holy Infant Nursery School.

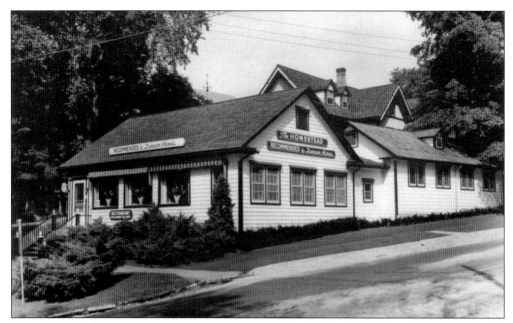

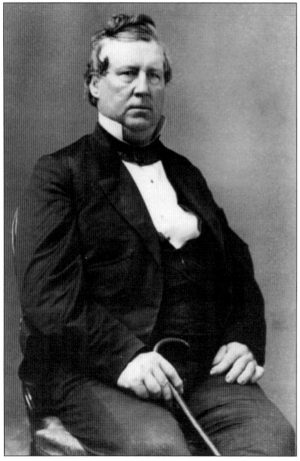

THE HOMESTEAD INN. This structure, which stands at the corner of Elm Street and Treadwell Avenue (5 Elm Street), wraps around the 1853 home of John Prime Treadwell. The house's roof, dormers, and chimney are visible in the photograph. The Homestead Inn was included in the tour guide of the American Automobile Association beginning in 1988, due to the efforts of innkeepers Rolf and Peggy Hammer. (Photograph by Harold I. Hunt.)

JOHN P. TREADWELL. Born in 1811, John Prime Treadwell was the son of Samuel and Jane Prime Treadwell. He married Mary Esther Lockwood on December 8, 1841. His son, John P. Jr., married Millie C. Booth, daughter of Charles Booth. John Sr. was president of the Village Improvement Society, which was organized in 1871.

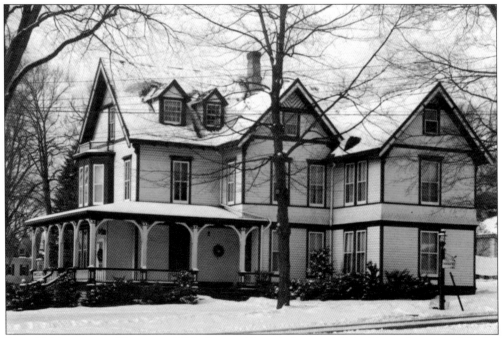

JOHN P. TREADWELL HOME, C. 1935. Pictured here before its 1938 addition (see page 16), this was the residence of the Treadwell family from 1853 until 1915. An inn since 1928 (its first proprietor, Mary Philpot, managed it for almost 50 years), it was the leading hotel in the area. The addition, originally a restaurant, was converted into motel rooms in 1955. (Photograph by Harold I. Hunt.)

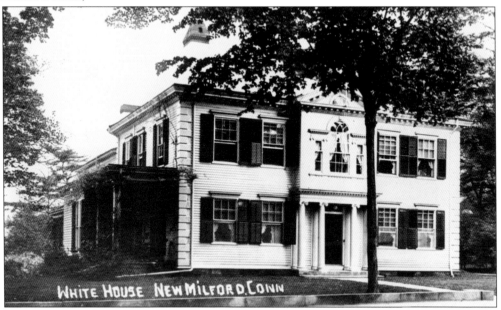

THE WHITE HOUSE INN, C. 1930. Better known as the Elijah Boardman house (now home to the law firm of Cramer & Anderson), this structure was built in 1793 by William Sprats. It was in the Boardman family up until the 1930s, and in 1960, it was the Colonial Funeral Home. It was restored in 1973 when it became a law office.

17

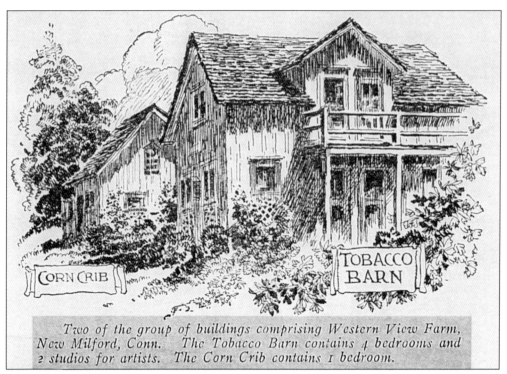

Two of the group of buildings comprising *Western View Farm, New Milford, Conn. The Tobacco Barn contains 4 bedrooms and 2 studios for artists. The Corn Crib contains 1 bedroom.*

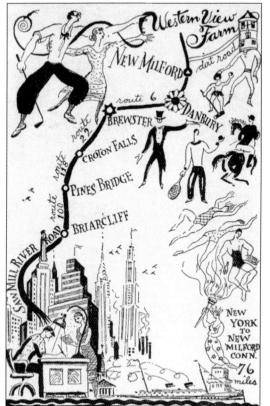

WESTERN VIEW FARM. Situated in the Chestnut Land section of New Milford, this summer resort provided lodging in renovated farm structures. Opened in the 1920s, it attracted traveling artists to its studio spaces.

WESTERN VIEW FARM ADVERTISEMENT. Manager Edward Ohmer of Western View Farm remodeled one of the barns on the property into a theater and organized the Haybarn Players, an amateur theater group that provided entertainment for his guests. New Milford's Edith Newton, an artist who came to town in 1917, designed the scenery for the productions.

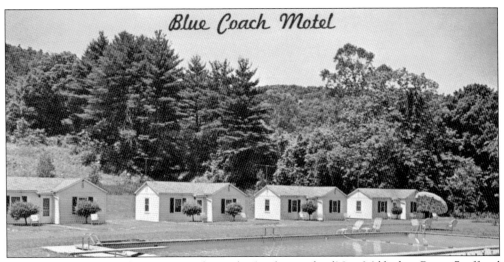

BLUE COACH MOTEL. These cottages, located 1.5 miles north of New Milford on Route 7, offered complete service by owner John Mutis. The property is now known as the Cottages at Kent Road, and the Olympic-size swimming pool no longer exists.

KENWOOD LODGE. This resort offered luxurious sleeping accommodations, swimming, tennis, and handball courts, a baseball field, and Rotisserie Restaurant. The lodge was conveniently located two miles from the New Milford train station. It was owned and operated by Samuel and Sarah (Lasky) Levenstein. For "John" and "Flo," who signed this postcard, it was the place to celebrate their second honeymoon in 1948. It is now the location of Chatsworth Village at 248 Danbury Road. (Photograph by Landis & Alsop.)

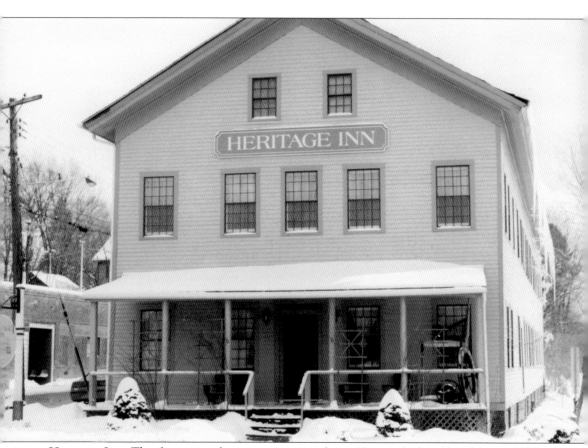

HERITAGE INN. This former warehouse was converted to a 30-room bed-and-breakfast in 1988. It is one of three tobacco warehouses in New Milford listed in the National Register of Historic Places. The other two are the J.S. Halpine building at the corner of West and Mill Streets, and the C.F. Schoverling structure at 1 Wellsville Avenue. These buildings are also included in New Milford's Center Historic District. For decades, 34 Bridge Street was called Green's Warehouse. Its original historic name was the E.A. Wildman Co. Tobacco Warehouse. It was built by Julius Bunzl and Henry Dormitzer of New York in 1870, conveniently next to the railroad tracks. In 2008, it hosted the stars of Rebecca Miller's film *The Secret Lives of Pippa Lee*, including Alan Arkin, Keanu Reeves, Wynona Ryder, and Robin Penn-Wright. The movie was filmed in New Milford and surrounding towns.

Two

WHERE TO EAT?

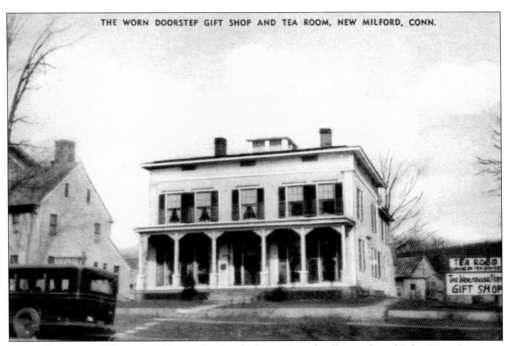

THE WORN DOORSTEP GIFT SHOP AND TEA ROOM, NEW MILFORD, CONN.

WORN DOORSTEP. "Worn with Hospitality" and where "Friend will meet friend," the Worn Doorstep began on Main Street in Bridgewater, Connecticut, in 1924. In 1929, the tearoom and gift shop was at 4 Main Street in New Milford, offering homemade fudge and candy. Francesca Starr was the original proprietor. In the 1930s, the restaurant became a separate entity operated by a Mr. Hasler. The house was built by John Mallett in 1845 for John Glover and Abigail (Mygatt) Noble.

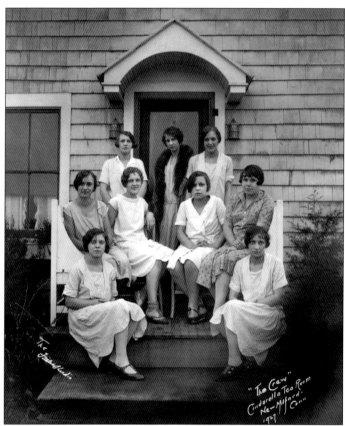

CINDERELLA TEAROOM. In 1927, "The Crew" posed for a photograph in front of the Cinderella Tea Room (later, Coffee House), located on the Schaghticoke Trail (Route 7) in New Milford. Irma C. Ambler was the proprietor. Elena Washington is seated second from left. (Photograph by Fuller Studio.)

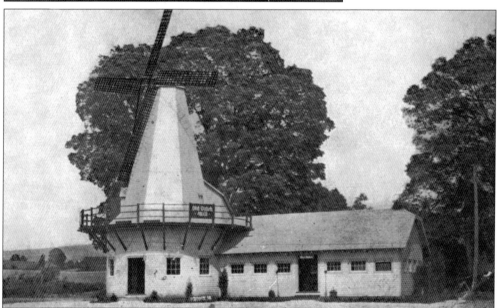

OLD DUTCH MILL. Another tearoom on the Schaghticoke Trail, also known as the Housatonic River Highway, was a popular stop for motorists traveling on Route 7 in the Gaylordsville section of New Milford. Mrs. George A. Ward was the manager. It was also called the Windmill Tea Room.

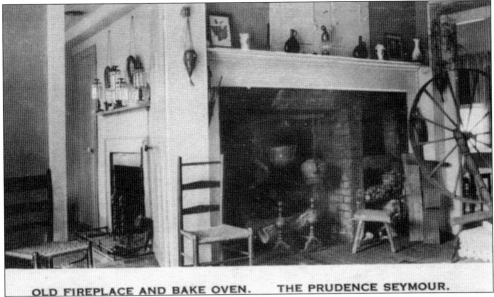

OLD FIREPLACE AND BAKE OVEN. THE PRUDENCE SEYMOUR.

PRUDENCE SEYMOUR. A tearoom–gift shop combination could also be found in the Northville section of New Milford in the 1910s and 1920s. The Prudence Seymour served breakfast, dinner, and supper and, of course, tea prepared in a Colonial kitchen. The premises were managed by a Mrs. Tallmadge and owned by Mary D. Parfitt. Prudence Seymour (born in 1755) was Mary's great-great-grandmother.

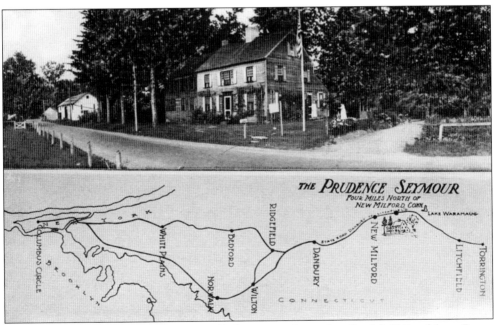

PRUDENCE SEYMOUR, EXTERIOR. The establishment was located on Litchfield Road (now Route 202), four miles from the center of New Milford and 84 miles from Columbus Circle in midtown Manhattan. The restaurant was listed in *Automobile Blue Book*, a series of road guides for automobile operators begun by Hartford, Connecticut, businessman Charles Howard Gillette.

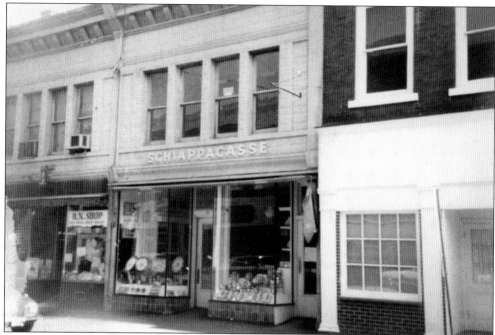

G.B. Schiappacasse's. Catering to some of the well-known personalities in the area, including Lowell Thomas and Frederick March, Schiapacasse's also provided a place to go for an ice-cream soda made from the fountain or homemade taffy and peanut brittle. The store, located at 21 Bank Street, was purchased from Rear Adm. Harry Knapp and his two sisters. Previously at 12 Bank Street, where Good Sport existed for several years, Schiappacasse's opened in 1903 and closed in 1975.

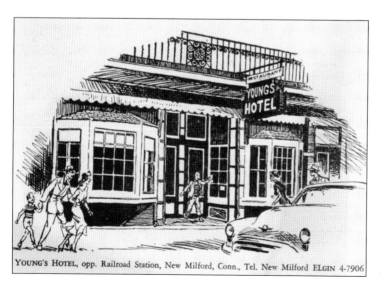

YOUNG'S HOTEL, opp. Railroad Station, New Milford, Conn., Tel. New Milford Elgin 4-7906

Young's Hotel Restaurant. Known for their "delicious home-made pies and desserts, steaks and chops," the restaurant at Young's Hotel was the place for salesmen, hatters, and those who worked at nearby upholstery factories and creameries. It was owned and operated by T.F. Young until Edward B. Dyer took over in the 1940s.

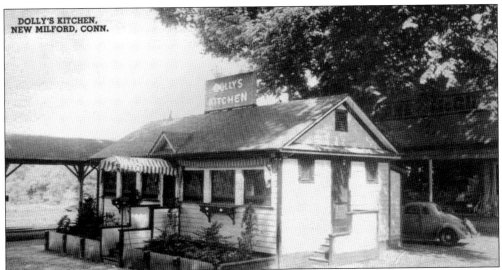

DOLLY'S KITCHEN. Not far from Young's Hotel, on the opposite side of Railroad Street, this small building next to the train tracks was erected in 1890. The awnings no longer exist, but the small gable over the entrance does. Today, 73 Railroad Street is Dolly's Wine Boutique.

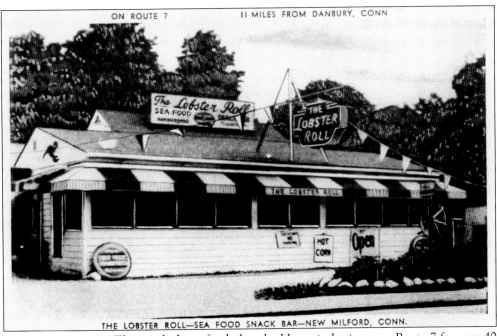

THE LOBSTER ROLL. This roadside seafood place had been in business on Route 7 for over 40 years when this postcard was printed. Besides steamed clams, live-boiled lobsters, and shrimp dishes, landlubbers could also sit down for a hamburger or hot dog, and there was "Always a Daily Special."

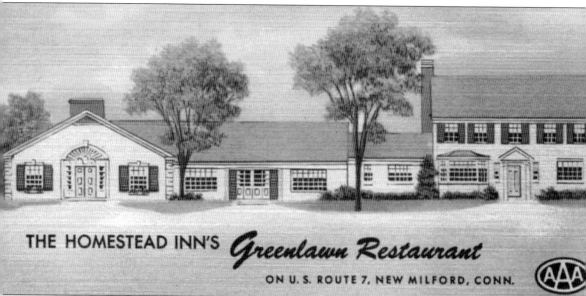

THE HOMESTEAD INN'S *Greenlawn Restaurant*

ON U. S. ROUTE 7, NEW MILFORD, CONN.

HOMESTEAD INN'S GREENLAWN RESTAURANT. Located on six scenic acres on the Housatonic River on Route 7, the Greenlawn had three dining rooms, a mural bar, and a 500-foot terrace overlooking the river. In the 1950s, its popularity could be felt on Railroad Street as Young's Hotel restaurant began to decline. New Milford Hospital's dinner dances were held at the Greenlawn. It was recommended by the American Automobile Association, founded in 1902. Greenlawn was also endorsed by Duncan Hines, a traveling salesman whose lists of recommended places to eat were first given to friends as Christmas presents. In 1940, restaurants receiving Hines's seal of approval were published in *Adventures in Good Eating*. (Duncan Hines household products soon followed.) In 1980, Connecticut Memories had a small antique shop at this complex. For almost 30 years, 266 Kent Road had been the home of Hank's Used Furniture and Antiques.

Three

Way to Go

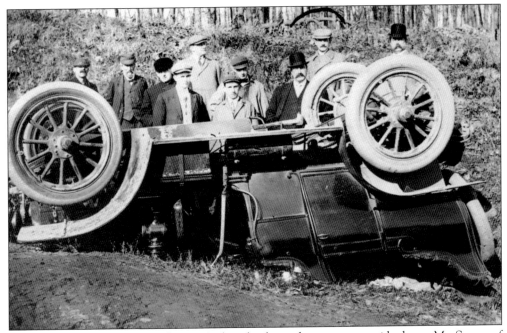

Winton Model K. In November 1910, the wheels on the car went upside down. Mr. Sperry of Northville was at the helm. After the upset, the rear door was opened, and several children came out unharmed, owing to the very high back of the car. Gus Northrop is at extreme left, and J.H. Nettleton is second from right.

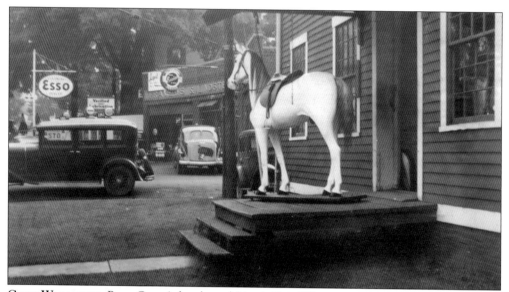

CHIEF WARAMAUG. Perry Green's four-legged friend, Chief Waramaug, checks out the competition from his post on the porch of the Green Warehouse, looking east from the corner of Bridge and Middle Streets. The wood and papier-mâché horse arrived by another competitor in 1918, which he viewed when facing north in later years: the railroad. When Green closed his warehouse in 1987, he donated Chief Waramaug to the New Milford Historical Society & Museum.

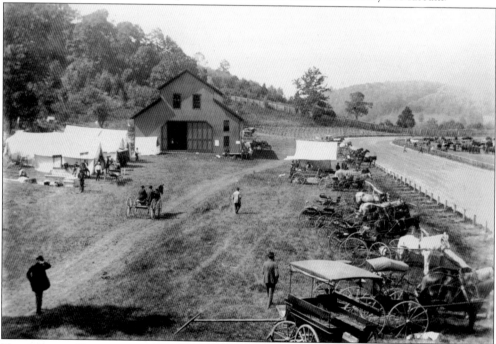

NEW MILFORD FAIRGROUNDS. The fairgrounds were located on Fort Hill. When this photograph was taken around 1895, the New Milford (later, Housatonic) Agricultural Association held its 17th Annual Fair. The half-mile racetrack can be seen on the right. The association disbanded in 1907, and the property was sold to T.F. Young, who used a portion of it to grow tobacco. (Courtesy of Frank P. Meloy.)

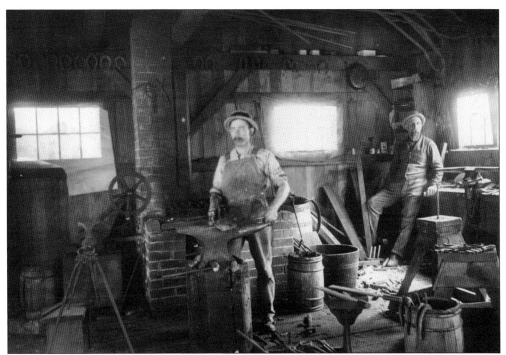

BROWN'S FORGE. Seen inside the blacksmith shop are Nathaniel Ashman (at anvil) and Fred Chase. A venture begun by Homer and Henry S. Brown in the Gaylordsville section of New Milford in 1871, this forge replaced an earlier blacksmith shop on Long Mountain Road. The brothers learned the business from Henry S. Disbrow. In 1950, Nat Ashman was running the business. (Courtesy of C.H. Evans.)

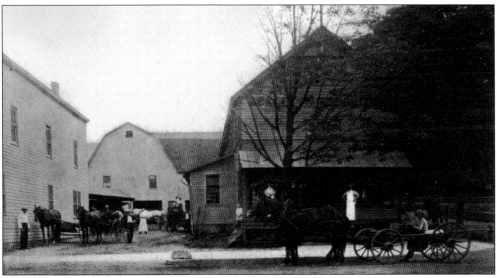

T.F. YOUNG'S STABLE. Thomas F. Young was a bartender at the New Milford House and, eventually, proprietor of the hotel on Railroad Street. The hotel's stable is on the left. To the rear and at right is the store of Ackley, Hatch, and Marsh. It is believed that this is the area where the Great Fire of 1902 began.

L. N. JENNINGS,
Livery, Feed and Sale Stables,
CARTAGE AND EXPRESS BUSINESS.

ALSO, DEALER IN

ICE.

OFFICE, 31 BANK ST.

L.N. JENNINGS LIVERY STABLE. Jennings established his livery business at his father's grocery store on Bank Street. In addition, he was an agent for Adam's Express, a delivery company incorporated in 1854. L.N. Jennings also sold cigars and tobacco. Jennings was one of the first foremen of the Water Witch Engine Company, No. 2.

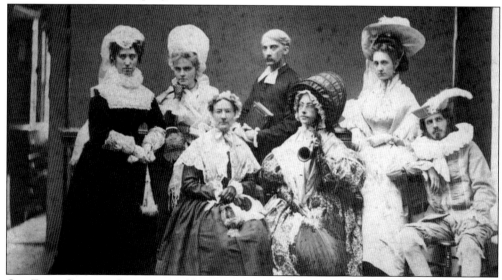

OLD FOLKS CONCERT. Lawrence Noble Jennings is the man in costume in the second row, center. The other participants are, from left to right, as follows: (first row) Alice E. Bostwick, Nancy F. Mygatt (with earphone), and William F. Bennett; (second row) Helen Boardman, Lottie Bennett, Jennings, and Carrie Mygatt. Jennings was the son of Harvey and Jane (Weller) Jennings. He was born in 1839 and died in 1909.

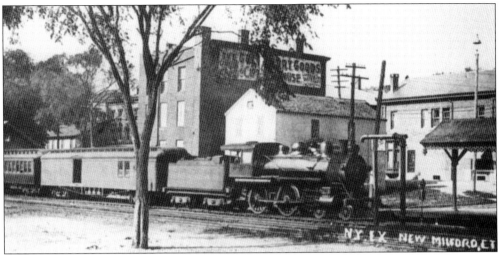

IRON HORSE, C. 1925. The Housatonic Railroad was opened from New Milford to Bridgeport in 1840. Daniel Marsh was appointed station agent. In 1892, it was leased to the New York, New Haven & Hartford Railroad, which merged with Penn Central in 1969. Passenger service to and from New Milford ended in 1971.

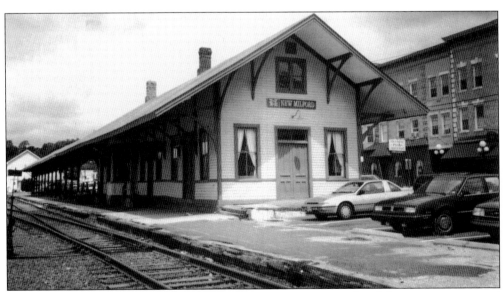

NEW MILFORD RAILROAD STATION, C. 1990. The Housatonic Railroad Company constructed the depot in 1886, and the town of New Milford purchased it from Conrail in 1981. The station has been restored inside and out and is now home to the New Milford Chamber of Commerce. (Courtesy of Howard Peck.)

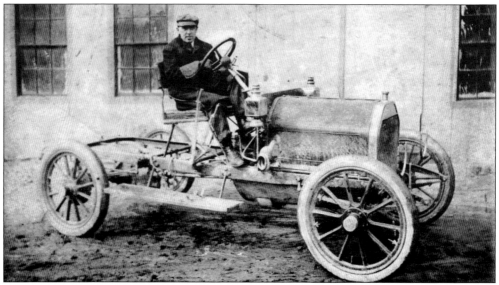

BEACH AND DISBROW GARAGE. Augustus H. Floyd sits at the wheel of a vehicle at the Beach and Disbrow Garage. The first horseless carriage in New Milford appeared on April 20, 1900. Gus Floyd, a mechanic, lived on Grove Street in New Milford.

The George A. Lewis Co.

LEO W. YOUNG, Mgr.

AUTOMOBILES

PARTS **ACCESSORIES** **SUPPLIES**

TELEPHONE 557

Bridge near Main Sts. New Milford, Conn.

GEORGE A. LEWIS COMPANY. Lewis's Chevrolet dealership was located on Bridge Street in the 1920s and 1930s. Some dealerships and garages in New Milford at that time sold makes and models that no longer exist: Hupmobile, Moon and Diana Motor Cars, Oakland, Hudson, Essex, and recently, Oldsmobile and Pontiac.

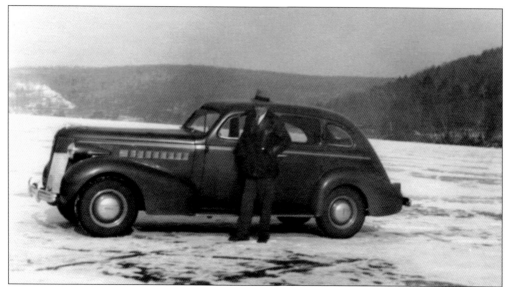

1937 Buick. Showing off his four-door sedan on something other than pavement (most likely Lake Candlewood), Howard Nettleton probably purchased his Buick from the Park Garage on 20 Danbury Road in New Milford. The business grew into Park Cadillac and moved to 149 Danbury Road. It ended its General Motors franchise at the end of 2008. (Courtesy of H. Nettleton.)

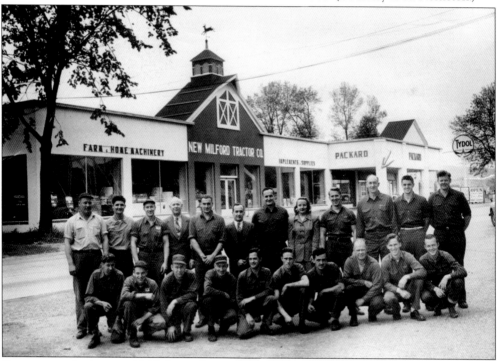

Southworth's, August 1948. Posing here are, from left to right, the following: (first row) Edward Targreen, Fred Roberts, Charley Vanderhauf, Jack Sommers, Roger Newkirk, James Williams Jr., Harry Shanks, Fred Winhurst, Grant Pope, and Don Whitacre; (second row) Henry Buckingham, Danny ?, Joe Krasky, Wesley Parcels, Phil Lagrotto, Frank Lagrotto, Guy Lagrotto, Dorothy Kustosz, Burt Monson, Don Emmons, Rutlage Curtis, and Leo Cass. (Courtesy of Jim Williams.)

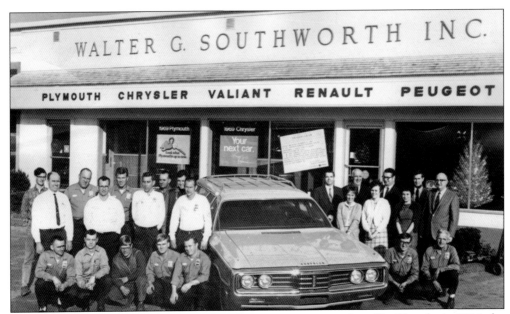

WALTER G. SOUTHWORTH, C. 1969. Before the minivan was introduced by Chrysler in 1984, the family "truckster" came in the form of the station wagon. Southworth had been at 5 Danbury Road on "Route 7 at the bridge" since 1953. There was also a Southworth dealership in Kent, Connecticut. (Photograph by Robert P. Pielli.)

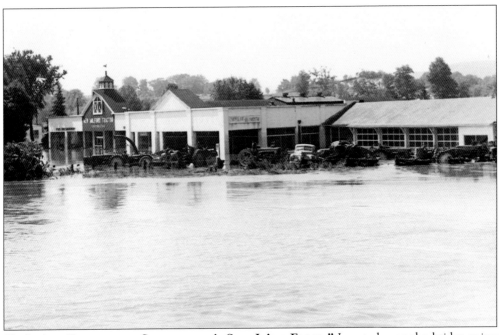

"IT ISN'T A FLOOD UNTIL SOUTHWORTH'S SAYS IT'S A FLOOD." Located near the bridge going into downtown New Milford, Southworth's was always prone to flooding when the Housatonic River rose. The process of moving cars to higher ground, as well as the economy, factored into the decision to close Southworth's sales and service departments in 2012.

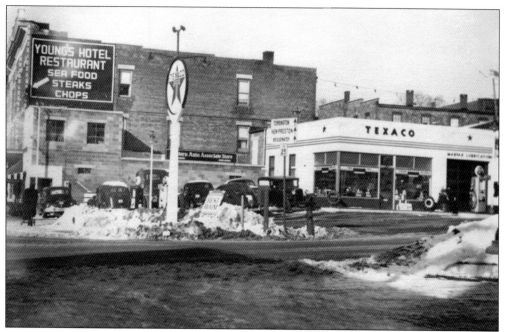

GET THAT GASOLINE. Cuddy's Texaco, a two-bay station at 45 Bridge Street, was built by the C.M. Beach Company in 1949. Its predecessor was the Warner and Disbrow general store. Prior to that, it was the location of a wagon shop, cider distillery, blacksmith shop, and the Noble Brothers button factory.

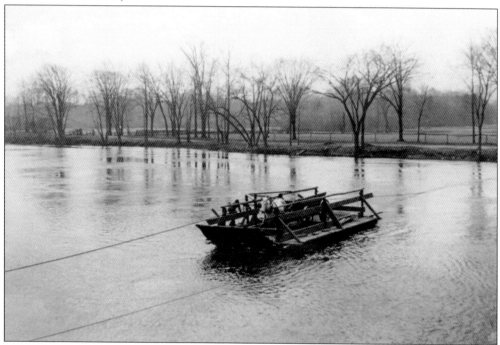

CROSSING THE HOUSATONIC. An alternative to a washed-out bridge, this ferry crosses the Housatonic River around 1902. New Milford's first bridge across the Housatonic was built in 1737 and lasted all of three years before it was swept away. (Courtesy of Frank P. Meloy.)

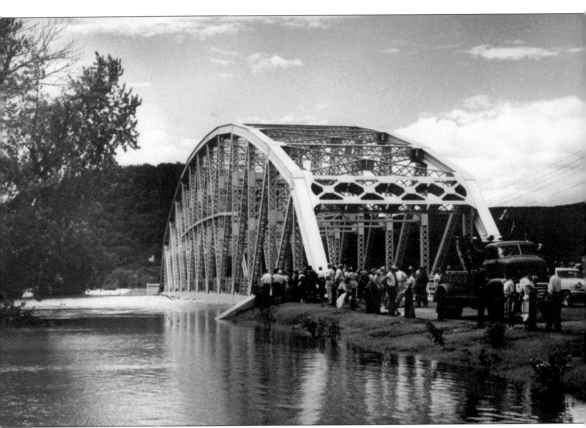

NOT THE WAY TO GO. The swollen Housatonic River had reached the top of Veterans Bridge in 1955. This photograph, looking west toward Route 7, shows the effect of the combination of Hurricanes Connie and Diane and an October storm. Veterans Bridge was only two years old at the time, and the metal truss structure, with 1930s-designed latticework and v-lacing beams, was slammed with the debris carried by rushing waters. The deluge began on Friday, October 14, and streets on this side of the river (West Street, Spring Street, and Housatonic Avenue) were flooded, and water extended to the edge of the railroad station. Robertson Bleachery also saw damage, and the Southworth dealership's crew was so busy moving vehicles, they were stranded until the fire department gave them a line of rope to assist them in wading through three feet of water to dry land.

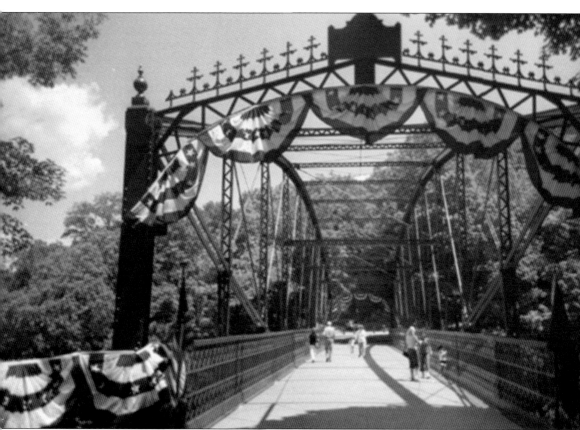

LOVERS LEAP/FALLS BRIDGE. "1895, Built by the Berlin Iron Bridge Co. of East Berlin, Conn. Douglas and Jarvis Pat. APL '16' 1885. F.E. Starr, C.B. Ackley, J. LeRoy Buck, Selectman," so reads the plaque on top of the lenticular truss bridge that crosses the Lake Lillinonah section of the Housatonic River. The bridge, part of Lovers Leap State Park, was named a National Register of Historic Places site in 1976. On the State Register of Historic Places is the nearby ruins of Bridgeport Wood Finishing Company, which operated on the banks of the river from 1881 to 1927. The site can be accessed via Lovers Leap State Park. The Friends of Lovers Leap State Park, started in 2004 by former state representative Jeanne Garvey Stax, made possible a 40-car parking lot at the park. The bridge was rehabilitated in 2007, and the group hosted a dedication and opened the park to pedestrian traffic on June 16.

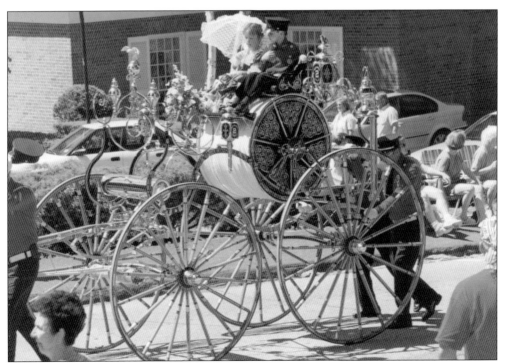

PARADE CARRIAGE. This ceremonial vehicle was purchased new in 1903 from Portland, Connecticut, by the Water Witch Hose Company, No. 2. It is seen here in the Memorial Day Parade in 1999. It was restored in 1960 and has won several awards. The company was organized in 1863, and its current firehouse is located at 8 Grove Street.

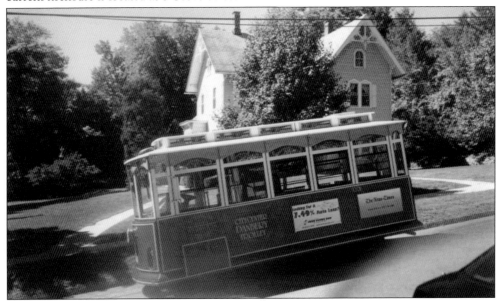

CLANG, CLANG, CLANG. Looking like one of the set pieces from *Mister Rogers' Neighborhood*, Danbury's City Center trolley makes its way down Aspetuck Avenue in New Milford. The car was borrowed by the New Milford Historical Society & Museum for a tour of buildings that belonged to the now-defunct Ingleside School. The event coincided with an exhibit about the school.

Four

(S)HE'S IN THE ARMY NOW

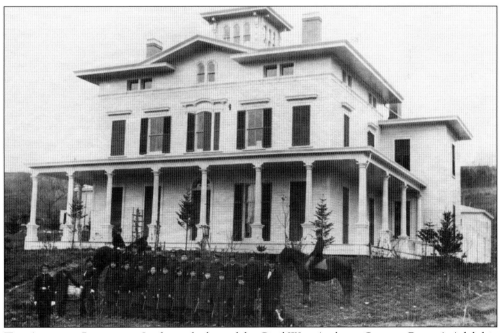

THE ADELPHIC INSTITUTE. In the early days of the Civil War, Ambrose Spencer Rogers's Adelphic Institute, a military school for boys, was a place to train young men to become officers for the Union army. The building still stands, located on Beard Drive in Prospect Common. It was the former residence of Charles and Mary Beard, noted American historians.

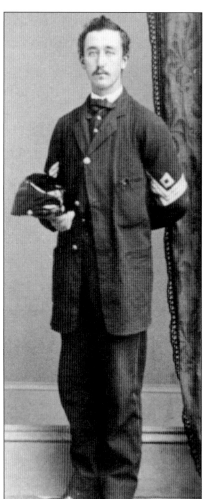

CHARLES N. IRWIN. Irwin enlisted on September 14, 1861, in Company I, 8th Regiment Infantry. He mustered in as sergeant and was promoted to first sergeant in 1862 and second lieutenant in 1863. He was wounded at Antietam, Maryland, on May 5, 1862. He died at Chapins Farm, Virginia, on September 29, 1864.

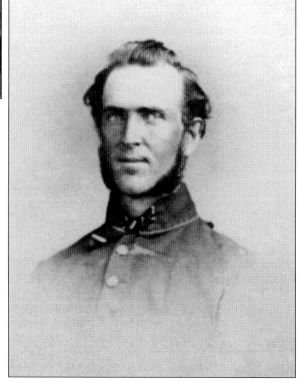

DAVID E. SOULE. Soule was born on March 4, 1838, the son of John and Lucinda (Whitehead) Soule. He was made corporal when he enlisted in Company H, 2nd Regiment Heavy Artillery on August 6, 1862, and was promoted to second lieutenant. In 1866, he married Sarah M. Sullivan, who died in 1891. He married Carrie Hine in 1892. David Soule died on June 9, 1919.

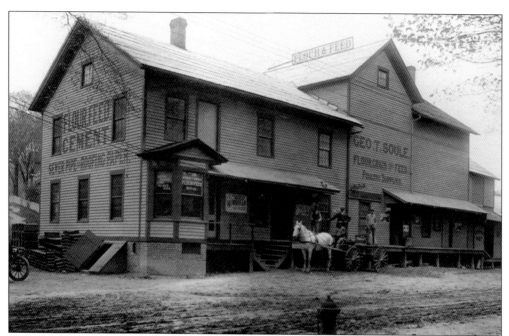

Soule Flour, Grain, and Feed. David E. Soule was in the tobacco business and partnered with his brother at a firm on West Street. The brothers built 75 houses between the mid-1860s and 1880, as well as warehouses and store buildings. They partnered with the Schoverlings and became the town's largest tobacco-packing enterprise.

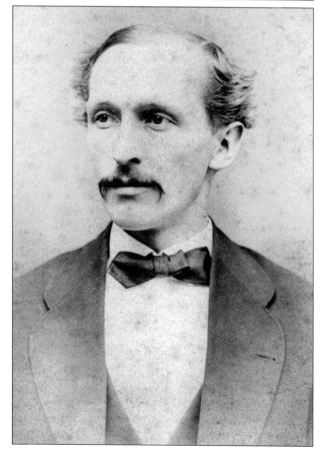

Col. Charles D. Blinn. Born in Cornwall, Connecticut, on August 26, 1840, Blinn was the son of Sturges L. and Caroline M. (Nettleton) Blinn. He saw action at Georgia Landing, Irish Bend, Port Hudson, Donaldsonville, Cane River Ferry, and Cedar Creek. He was promoted from captain (Company C, 13th Regiment Infantry) to lieutenant colonel, then to colonel. Blinn came to New Milford after the war about the same time he married Harriet C. Pratt. He had a dry-goods business with Charles H. Booth on Bank Street.

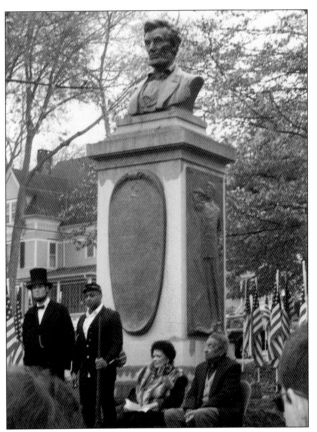

LINCOLN HERM. At the top of the green, just below the New Milford Historical Society & Museum, a Civil War veteran donated a memorial to "The Memory of the Soldiers and Sailors of the Union Army and Navy Who Served in the Civil War and to Abraham Lincoln." It was dedicated on Memorial Day, May 30, 1912. On November 17, 2013, the historical society held a ceremony (left) to mark the 150th anniversary of the Gettysburg Address. For this event, Lincoln (portrayed by Howard Wright) made an appearance. Shown are, from left to right, Wright, Ray Dunbar Smith, Frances L. Smith, and Ray Smith. Also at the event, an Underground Railroad plaque, located beneath the monument, was unveiled. Shown below, it was designed and created by Ray Crawford.

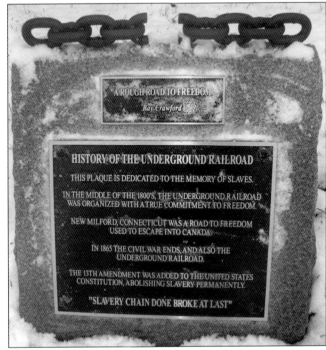

ANDREW BURTON MYGATT. The son of
Henry Seymour and Nancy (Faxon) Mygatt,
Andrew was born on October 9, 1880, and
enlisted on September 2, 1917, as sergeant,
first class, 20th Division. He died on July
2, 1923. The Veterans of Foreign Wars Post
No. 1672 on Avery Road in New Milford
was named for Andrew B. Mygatt in 1947.

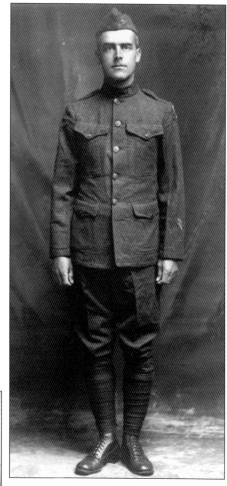

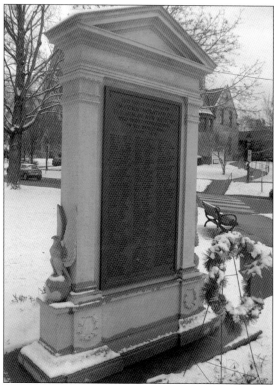

WAR MONUMENT. In 1920, a memorial
was purchased by popular subscription
and erected on the village green. The
side facing south lists New Milford
citizens who served in World War
I. The reverse shows those who
participated in the American Civil War.

43

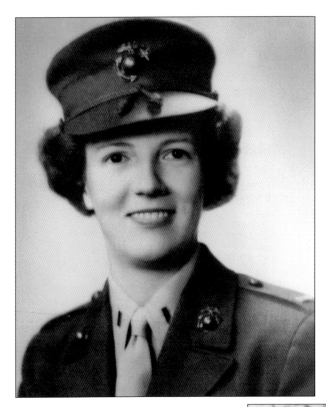

LT. ELIZABETH ANN NOBLE. "Betty" Noble enlisted on March 25, 1943, and was one of the first women officers in the US Marine Corps in World War II. Born on November 7, 1917, she was the daughter of Clement and "Blossom." She was married to John T. Brickley. Betty died on May 1, 2001.

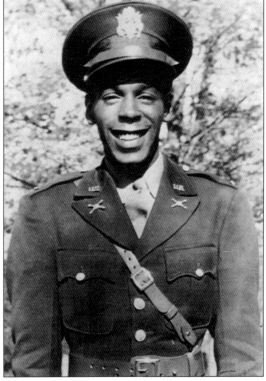

2ND LT. ROBERT J. PEAGLER JR. Peagler was one of seven brothers who served in World War II. He and his brother John both died in service. Robert was in the Army and died in Okinawa; his family received his Distinguished Service Cross after the war. John Russell Peagler served in the Navy and died in service in 1946. Their father, Robert James Peagler, was in the US Army in World War I.

Five

TAKE THAT TO THE BANK

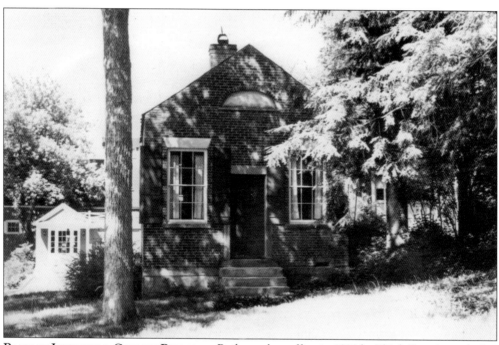

BANK OF LITCHFIELD COUNTY BUILDING. Built as a law office in 1820 by Elijah Boardman for his son, this small brick building on Main Street has been a dry-goods store, photographer's studio, and an office, but law was never practiced here. This building became the first bank in New Milford in 1852. The Bank of Litchfield County was organized with capitalization of $100,000. Frederick G. Chittenden was its first president.

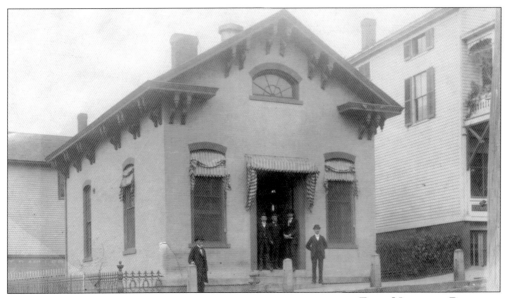

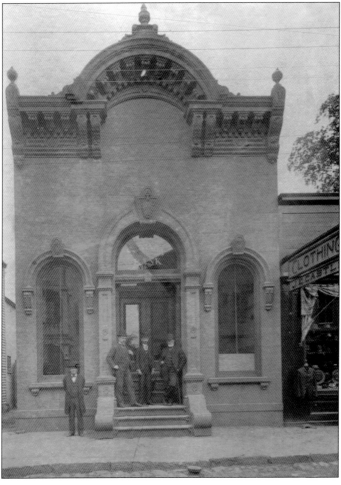

FIRST NATIONAL BANK, 1898. In 1865, the Litchfield County Bank became a national bank. Prior to that, it had moved from Main Street to Bank Street. Bank Street was opened in 1847, but it was first called Wall Street. Pictured here are, from left to right, Andrew B. Mygatt, Joseph H. Nettleton, Henry S. Mygatt, Robert E. Murphy, and E.J. Sturges.

NEW MILFORD SAVINGS BANK. On August 23, 1858, George Booth deposited $39 at the New Milford Savings Bank, located in an office on the south side of Bank Street. This Portland stone building on the north side of Bank Street was erected in 1877. Standing outside the building are, from left to right, Charles Randall, Leroy Randall, E.T. Emmons, and Ralph Canfield. (Photograph by William H. Fuller.)

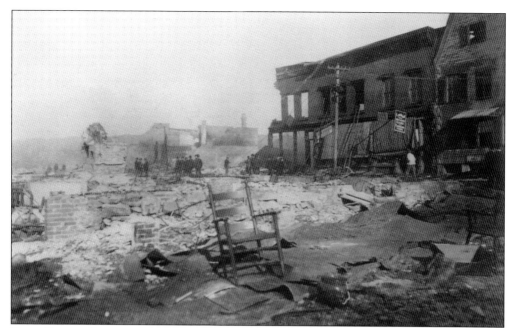

BANK STREET, LOOKING NORTHWEST. The conflagration of May 5, 1902, left downtown New Milford in shambles. This photograph was taken from the corner of Bank and Main Streets, in the vicinity of the ruins of the New England House. "The blow was like lightning from a clear sky and on a beautiful evening in May, the village prosperous, its inhabitants happy, the sudden weight of disaster descended," reported the *New Milford Gazette.*

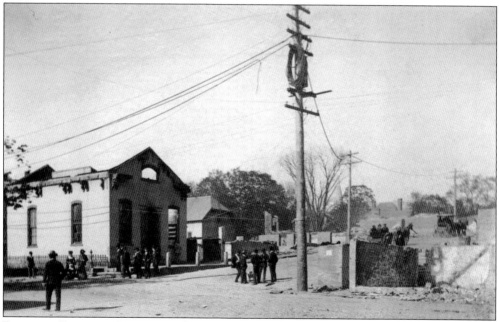

BANK AND RAILROAD STREETS. Onlookers congregate around the wreckage of the First National Bank. The destroyed building on the opposite (southwest) corner on Bank Street was constructed in 1841 by George N. Mallory. It was the Rail Road House in 1849 and the Housatonic House in 1855.

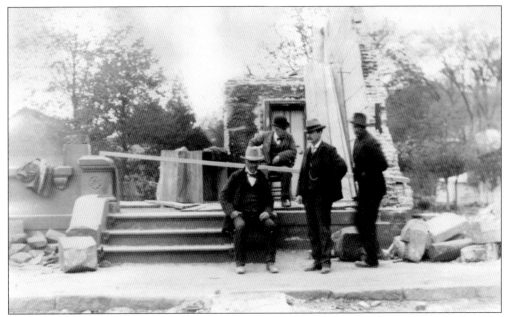

WE WILL REBUILD. About all that was left of the New Milford Savings Bank were the records in the vault. These were taken to Main Street, where the bank set up temporary locations, first at Town Hall and then in the Randall-Green building near Bridge Street, currently the Allen Building.

RECONSTRUCTION. A month after the great fire, Bank Street was already rising from the ashes. In the background of this west-facing photograph is the intersection of Main and Bank Streets. The one-story building on the southeast corner was a temporary structure that served as a restaurant. It was built by George and Mary Pixley, who ran the New England House before the fire.

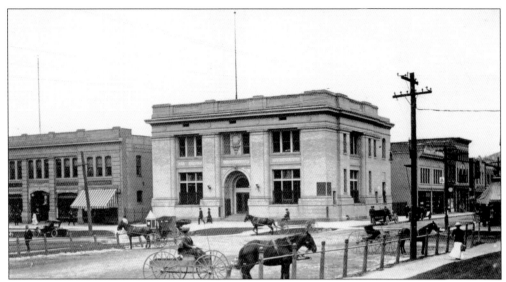

UNITED WE STAND. The United Bank Building, on the south corner of Bank and Main Streets, was erected around 1902. George and Mary Pixley sold this property at 19–23 Main Street to First National Bank, which erected the current edifice. Its occupants were First National Bank and New Milford Savings Bank.

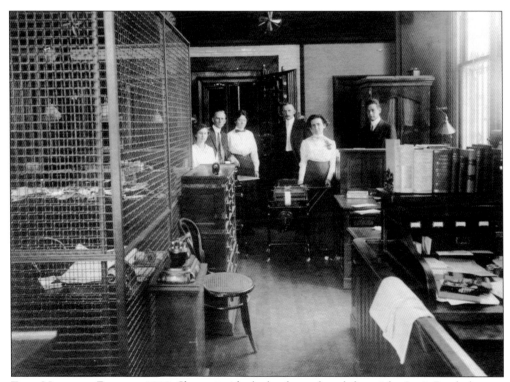

FIRST NATIONAL BANK, C. 1912. Shown inside the bank are, from left to right, Jessie Bartholomew, Frank Canfield, Helen Lawless, Rob Murphy, ? Ferriss, and Walter Van Sant. By the mid-1960s, the name was changed to Litchfield County National Bank. The institution offered drive-in service at 42 Main Street.

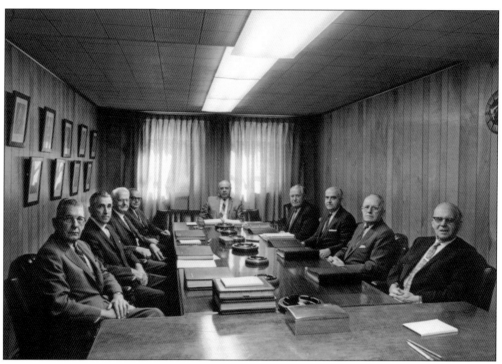

BANK BOARD OF DIRECTORS. In 1967, the directors of the New Milford Savings Bank were, from left to right, Russell V. Carlson, Ralph Camp, J. Theodore Rogers, Earl Robinson, Forrest D. Arnold (president), Michael Larson, Julian Stone, William X. Martin, and Milton Osbourne. (Courtesy of Russell V. Carlson.)

48 BANK STREET. After the Pixleys sold their property at the corner of Main and Bank Streets in 1902, they managed a resurrected New England House (with bowling alley) on Bank Street. In 1920, this building was converted into the Star Theatre by William G. Mock. An Art Deco facade was added in the 1930s. It has also been called the Twentieth Century New Milford Theater and the New Milford Theatre. Residents today call it the Bank Street Theatre.

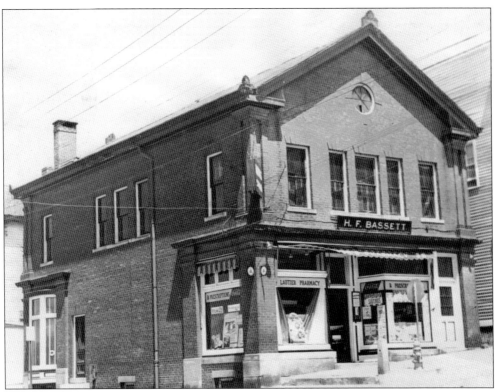

62 BANK STREET. For decades, Bank Street had bookend pharmacies, both located on the north side of the street. One was at the corner of Bank and Railroad Streets, the other at Bank and Main Streets. The H.F. Bassett building (pictured) was built after the Great Fire of 1902. Before the blaze, it was the location of the First National Bank.

HARRISON F. BASSETT. In 1928, Basset became the fourth owner of the drugstore that began on Railroad Street in 1841. He purchased the business from Charles Botsford. Bassett was a registered pharmacist who came to New Milford when he was 12.

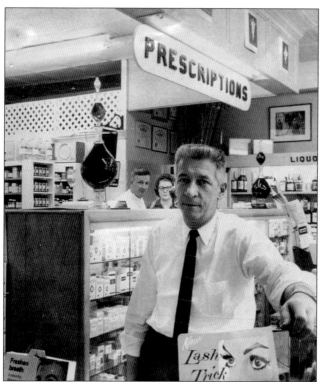

Victor F. Lautier. Lautier's Pharmacy began in 1952. Young and ambitious, Lautier set out to provide New Milford with its first medical building. A self-service elevator was installed here in 1956 to connect doctors' offices (one of which was for a female obstetrician) with the drugstore. The pharmacy was also expanded and renovated.

Lautier's Pharmacy, 38 Bank Street. Lautier's was the last pharmacy to occupy this spot before it changed to a newsstand and tobacco shop, known today as Archway News, established in 1993. The drugstore had an ice-cream counter and soda fountain, which were often manned by a New Milford High School student.

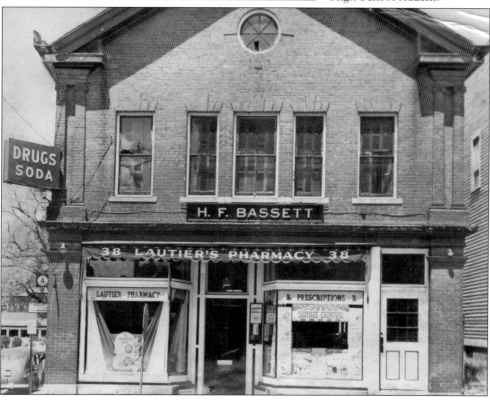

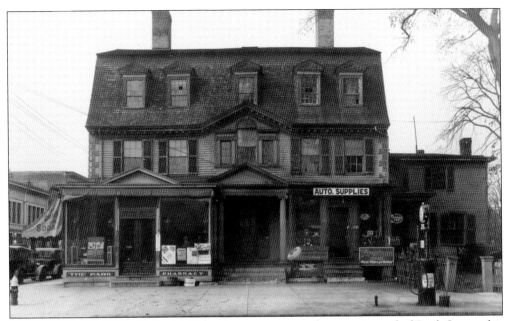

PARK PHARMACY, 2 BANK STREET. Like its competitor on the opposite end of Bank Street, this address has been home to several drugstores over the years. A survivor of the Great Fire of 1902, the once-elegant United States Hotel's beauty was still evident when it was razed in 1927. It was photographed by many, and local artist Edith Newton sketched it more than once. The entrance to the Park Pharmacy is on the left.

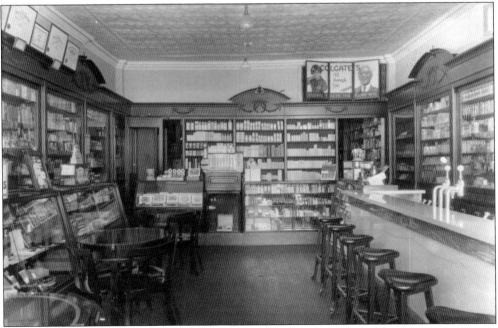

PARK PHARMACY, INTERIOR. About the time this photograph was taken in 1924, it was owned by William N. Noble, Claude P. Maxwell, and Gifford B. Noble. Before that, it was operated by pharmacist Stephen Evans. The drugstore featured a soda fountain and luncheonette. (Photograph by Fuller Studios.)

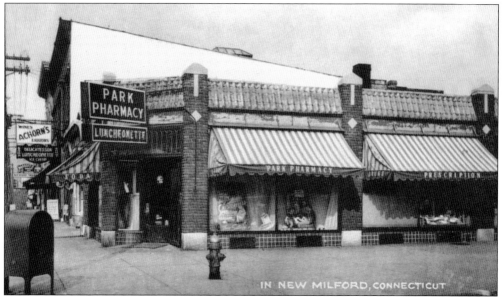

IN NEW MILFORD, CONNECTICUT

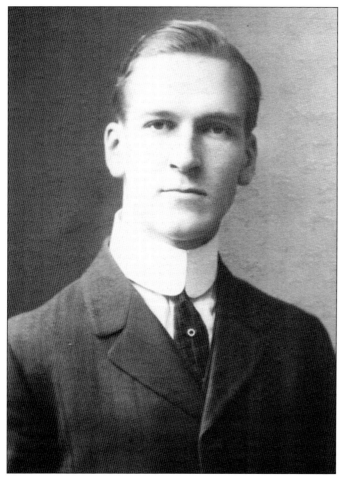

NEW PARK PHARMACY. Owner Gifford Noble had the United States Hotel demolished in 1927. He replaced the building with a one-story brick structure and kept the Park Pharmacy name. Its large storefront windows contained displays that caught the eyes of pedestrians and motorists alike. The large awnings provided temporary shelter from the elements.

GIFFORD B. NOBLE. Noble was a direct descendent of New Milford's first settler, John Noble Sr. Gifford was born on April 1, 1889, in New Milford, the son of William H. and Minnie (Henry) Noble. He was a graduate of Columbia College of Pharmaceutics in New York City. Noble died on March 26, 1966, in Niagara Falls, New York. (Courtesy of Brigette Shackleton and Peggy Addoms.)

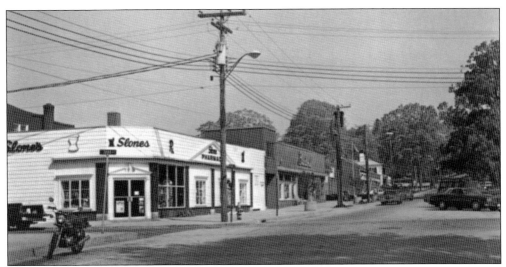

SLONE'S PHARMACY. In 1947, 2 Bank Street was sporting another look, and the drugstore was called Slone's Pharmacy. Benjamin Slone became owner in 1983. In 2004, Slone's was replaced by the New Milford Pharmacy until 2010, when it became Big Y Pharmacy. Big Y's occupancy was short-lived, when the grocery store on Kent Road expanded in 2012 to include a pharmacy. Big Y Pharmacy's relocation concluded the history of drugstores on Bank Street.

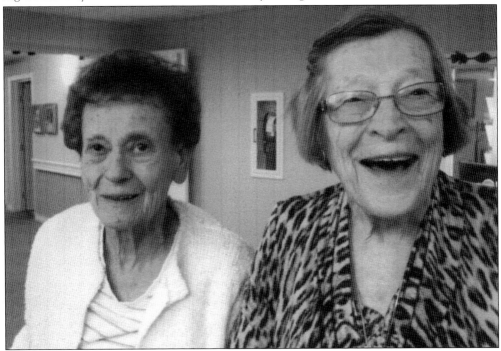

NANCY NOBLE BLACKMAN AND PEGGY NOBLE ADDOMS. Nancy (left) and Peggy are the daughters of Gifford B. Noble, pharmacist and a former owner of 2 Bank Street. Nancy and Peggy were also owners. When Peggy, a resident of Niagara Falls, paid a visit to New Milford in 2013, she was given a private tour of 2 Bank Street (then under renovation) by the current owner, Gary Goldring. The building is open now, occupied by Robertson Jewelers. (Photograph by Brigette Shackleton, courtesy of Shackleton and Peggy Addoms.)

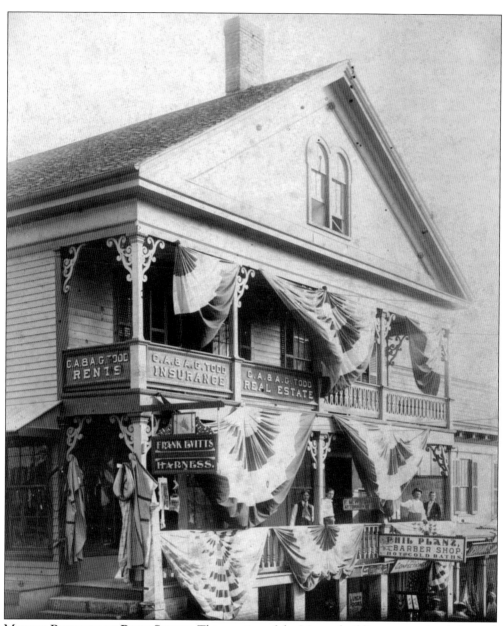

MYGATT BUILDING ON BANK STREET. This portion of the Mygatt building, conveniently located near the train station, contained Charles A. Peck's grocery store, Frank Evitts's harness shop, Phil Planz's barbershop, the office of attorney Fred M. Williams, and C.A. and A.G. Todd's insurance office. Currently, the location is home to Lucia's and the Alpenhaus restaurants. In the building farther south was a Western Union office, F.G. Bennett's (furnishings and undertaker), the *Housatonic Ray* newspaper, Blackman Jewelry, M.J. Gordon's Furnishing Goods, and Alex Levy Books (and stationery, toys, and cutlery). Behind the buildings were Emmons & Bray's blacksmith shop, P.M. Cassidy's sporting goods store, C.H. Jackson's grocery store, and the Sherman harness shop. The Mygatt building was destroyed by the Great Fire of 1902. Prior to the fire, it stood at 35–39 Bank Street. Today, it is at 51–67 Bank Street.

Six

It's All in the Game

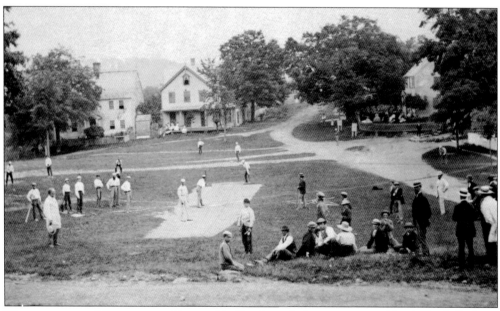

Washington vs. Weantinaug. Featured in Ken Burns's documentary and book *Baseball*, this is one of the first, if not the first, known photographs of a baseball game. It was taken on August 4, 1869, on the Washington Green, in Washington, Connecticut, with New Milford at bat. On the roster for the Weantinaugs were Robert Erwin, ? Addy, Joseph C. Wiley, Frank Hine, George Irwin, ? Jennings, Fred. Hine, ? Hurlburt, and ? Wheeler. (Photograph by Seth Landon.)

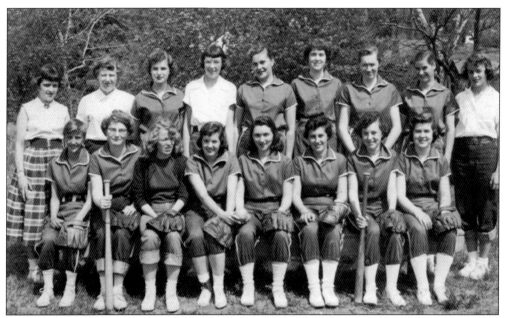

NEW MILFORD HIGH SCHOOL SOFTBALL TEAM. The Green Wave girls of 1956 are, from left to right, as follows: (first row) L. Beatty, P. Johnson, R. White, S. Weatherley, I. Csutoras, J. Steck, J. Warner, and R. Knittle; (second row) L. Kuhne, Miss Wagner (manager), D. Quenneville (coach), J. Allen, E. Roberts, C. Knittle, R. Blair, M. Douskey, and M. Crowley. (Courtesy of Jean Walter.)

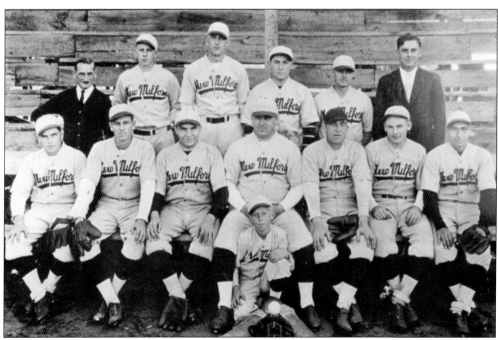

BASEBALL TEAM, C. 1935. Members of this team are, from left to right, (first row) Howard Faure, Fred Collins, Paul Travaglin, Frank Adams, Bill Marshall, Ken Law, and unidentified; (second row) Art Smalley, Ray Hagstrom, Sylvester Peet, Ben Travaglin, Ray Lumley, and unidentified. The batboy is Eddie Woyciechowski. The names were furnished by Merrill Golden in 1986.

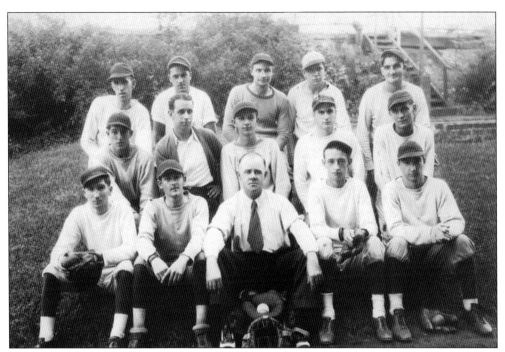

ROBERTSON BLEACHERY BASEBALL TEAM, 1931. Pictured here are, from left to right, (first row) Tom Feeney, Jim Mitchel, Nick McGraham, ? Paralak, and ? Pomykatis; (second row) Bill Robinson, ? Onorato, unidentified, Hugh Burnhart Sr., and ? Espitee; (third row) ? Murray, ? Hill, two unidentified men, and ? Raino. The Robertson Bleachery & Dye Works was located at the end of West Street.

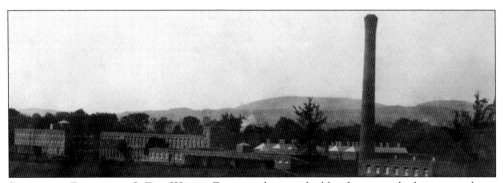

ROBERTSON BLEACHERY & DYE WORKS. For several years, the bleachery was the largest employer in New Milford. Built in 1917, the 120,000-plus-square-foot brick building processed an enormous amount of cloth for about half a century. In 1958, the New Milford Industrial Corporation took title. Harold Fischel purchased the property 40 years later for $1 million and spent thrice that amount on renovations. Today, it includes West Cove Marina.

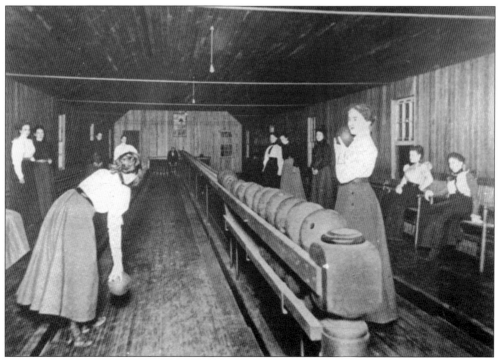

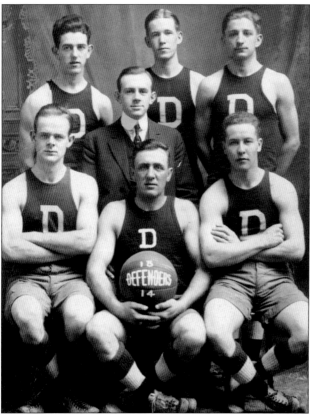

BOWLING FOR SCHOLARS. Sarah Northrop (Sanford) Black's Ingleside School for Girls (1890–1914) on Aspetuck Avenue provided numerous recreational activities for its students. A bowling alley and a billiards table were part of the Wigwam building. The athletic field is where a world record for girls' high jump was set in 1910. The campus was located where the Canterbury School has been since 1915.

NEW MILFORD DEFENDERS, 1914. Basketball was a game designed as an indoor sport for the cold months. J. Leo Murphy reported in 1914, "We have just finished a successful season. 25 games, 19 victories, six defeats." Pictured here are, from left to right, (first row) ? Halpine, ? Dunsford, and ? Chalmers; (second row) ? Moore, ? Hulton, and ? Stark. Murphy is the man between rows in suit and tie.

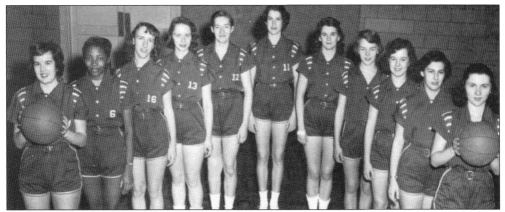

NEW MILFORD HIGH SCHOOL GIRLS' BASKETBALL TEAM. The players for 1956 are, from left to right, Susan Weatherly, Juanita Johnson, Loretta Young, Jeanette Ocif, Rose Ann Blair, Carole Knittle, Judy Stoddard, Marion Crowley, Janet Warner, June Steck, and Ilona Csutoras. The team ended its season with a 39-37 win over Litchfield. (Courtesy of Jean Walter.)

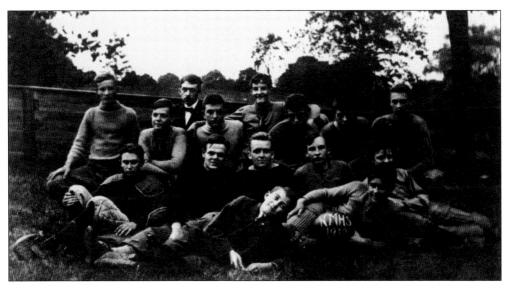

NEW MILFORD HIGH SCHOOL 1910 FOOTBALL TEAM. Pictured are, from left to right, (first row) R. Hatch (manager) and C. Penfield; (second row) G. Draper, T. Halpine, H.F. Hunter, T.C. Kyle, and C. Connell; (third row) D. Hungerford, H. Evans, J. Pettibone (principal), ? Lorch, R. Pomeroy, L. Sturges, G. Green, and H.H. Peck.

FOOTBALL AT YOUNG'S FIELD. Before sports and recreation were seen on this expanse, T.F. Young grew tobacco here. It became a park in 1907, and in 1941, the town took ownership from the New York, New Haven & Hartford Railroad Company. It includes basketball and tennis courts, a pavilion, playground, soccer and ball fields, and a skate park. The park is accessed from Young's Field Road and can also be approached from the steps that descend from the railroad/commuter parking lot (background). It is open to the public year-round. Other public venues that offer athletic activities are Clatter Valley on Old Farm Road, Emmanuel Williamson Park in Gaylordsville, Helen Marx Park on Housatonic Avenue, Northville and Sarah Noble Soccer Fields at the schools, Pettibone Park near the school, and Pickett District Road Ball Fields. For New Milford residents, Harrybrooke Park offers fields for sports.

Seven

WE ARE FAMILY

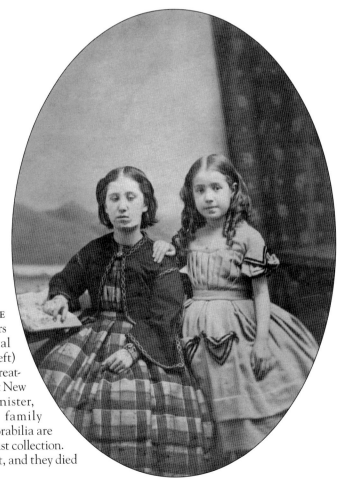

HELEN MARIA AND KATE TAYLOR BOARDMAN. Cofounders of the New Milford Historical Society & Museum, Helen (left) and Kate Boardman were the great-great-granddaughters of the first New Milford Congregational minister, Daniel Boardman. Their family heirlooms and traveling memorabilia are part of the historical society's vast collection. They were born five years apart, and they died five years apart.

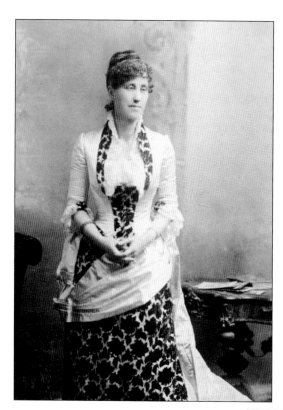

HELEN BOARDMAN. On January 12, 1915, Helen Boardman, Charles M. Beach, and Robert E. Murphy were appointed to a committee to present to the Connecticut State Legislature a draft of a charter by Frank W. Marsh for the organization of a historical society. The charter was approved on March 19, 1915.

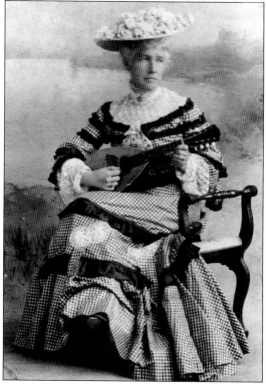

KATE BOARDMAN, 1903. In 1920, Kate willed the Boardman home to the New Milford Historical Society, with the stipulation that a room would be available for meetings of the Roger Sherman Chapter of the Daughters of the American Revolution, which her sister and mother organized in 1893. Kate and Helen were the daughters of Frederick and Harriet (Canfield) Boardman. (Courtesy of Irma Ambler.)

FREDERICK BOARDMAN. Frederick was a druggist with a business on Railroad Street beginning in 1841. This business was sold in 1865 to Albert Evitts, who was the historical society's president from 1936 to 1952. Frederick Boardman was born on July 20, 1817, to Judge David Sherman and Charlotte (Taylor) Boardman.

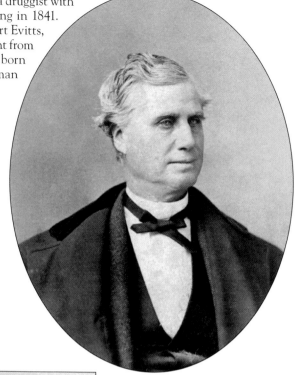

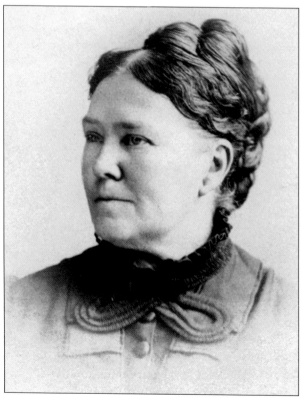

HARRIET CANFIELD BOARDMAN. Harriet was the daughter of Col. Samuel and Rebecca M. (Taylor) Canfield. Harriet married Frederick Boardman on September 17, 1845. They lived in the house of her father-in-law, Judge David S. Boardman, which Harriet sold in 1879. A new house was built on the corner of Main Street and Boardman Terrace. It was donated by Kate Boardman to the historical society in honor of David Sherman Boardman.

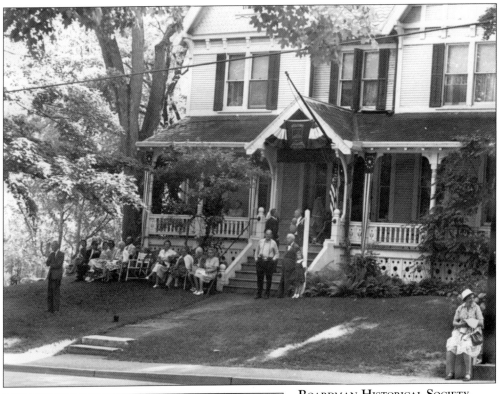

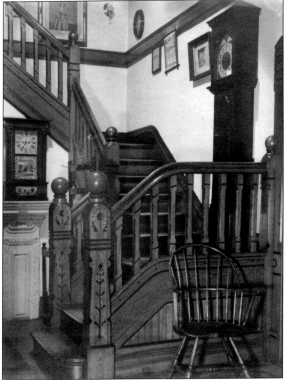

BOARDMAN HISTORICAL SOCIETY. Also known as the New Milford Historical Society, this Victorian house, built in 1882 at 55 Main Street, was the home of Harriet Boardman. Her daughters, Kate and Helen, also lived here with their aunt Mary Cornelia Boardman, daughter of David Sherman Boardman. The house, opened to the public in 1922, displayed many of the objects that were exhibited at New Milford's bicentennial celebration in 1907.

STAIRCASE, 55 MAIN STREET. Some of the Boardman treasures can be seen here at the museum when it was located on Main Street. The last Boardman to live here was Kate, who died in 1920. When the historical society sold the property to the New Milford Savings Bank in 1963, it left the former residence of Kate and Helen's great-uncle, Elijah Boardman, as the last house on the west side of Main Street.

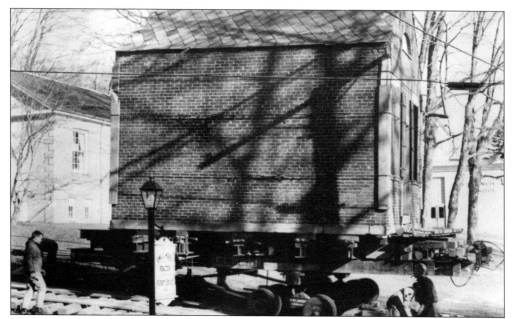

First Bank in New Milford. When plans to sell the historical society building on Main Street were under way in 1963, it was also announced that the original Litchfield County Bank structure would be moved to the society's property on Aspetuck Avenue. This building would complement the Knapp House there, which had been donated in 1955. The society had purchased the lot and the building on Main Street—part of Elijah Boardman's property—in 1939.

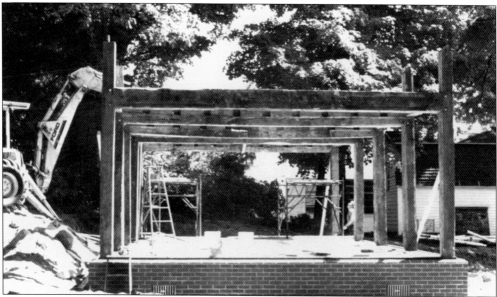

Boardman Mercantile. In 1796, Elijah Boardman had a store erected near his home at 51 Main Street. Previously, he had been in business with his brother Daniel. The business was dissolved when Daniel moved to New York. Elijah's business was sold in 1819, and the building saw several owners. In 1861, the structure was moved to Railroad Street. In 1988, it was sold to H.H. Taylor, who donated the building to the historical society in 1994. It was dismantled and reassembled on the society's property.

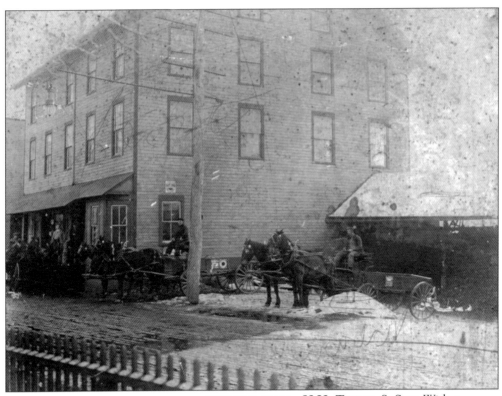

H.H. Taylor & Son. With a business that started in 1901, Harry Taylor Sr. was a building contractor early on. The aftermath of the 1902 fire had his builders busy constructing makeshift structures on the green. In 1927, the company was at 85 Railroad Street in a former grain elevator and mill built in 1887. A yard office and warehouse were built after the Boardman store was removed in 1994. (Courtesy of Joe Cats.)

Boardman Store at the New Milford Historical Society. Two hundred years after it was built on Main Street, the "Old Gambrel Roof," as it was sometimes called, was whole again and ready for visitors. Dedication was held on October 27, 1996, and participants included members of the Boardman family from Boardman, Ohio. In 1998, the society's reconstruction was awarded a citation from the New Milford Trust for Preservation.

FLORA GEER STILSON. When the historical society opened in 1922 on Main Street, the first curator, Flora Stilson, was on hand to greet visitors. One of the first organizers of the society, her name can be found on House Bill No. 111.86 incorporating the society "for the purpose of promoting historical and genealogical research, particularly in regard to the town of New Milford and its inhabitants, and collecting and preserving antiquarian and historical objects and records."

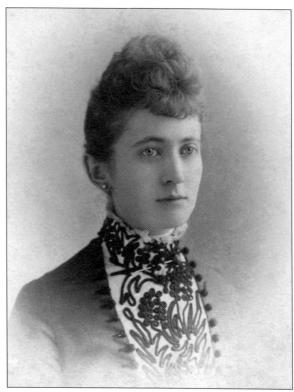

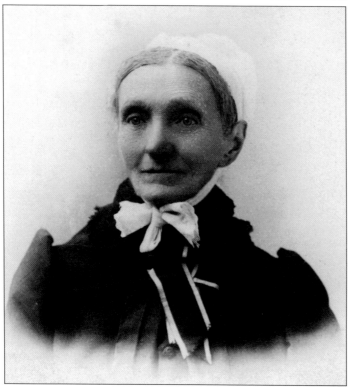

LORETTA BISHOP GEER. Flora Geer Stilson, the society's first curator, was born on October 2, 1865; her mother, also named Flora, died on the same day. The curator lived with her grandmother since Flora's birth. Flora's mother married Andrew T. Stilson on October 17, 1860. Andrew had a gristmill in New Milford and was a direct descendent of Benjamin Bostwick, the third settler of New Milford.

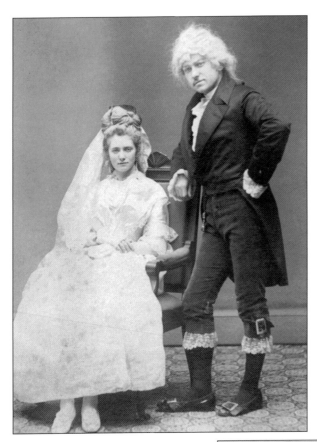

CHARITY DUSENBURY AND ICHABOD PETTINGILL. Flora G. Stilson (left) and Charles C. Barlow are outfitted for a Lady Washington party. Charity Dusenbury and Ichabod Pettingill were the names of the fictional characters they were portraying for the event. The event was probably held at the beginning of June to commemorate the first lady's birthday. Stilson was descended from two American Revolutionary patriots, Epenetus Platt and Benjamin Bostwick. (Photograph by J.E. Canfield.)

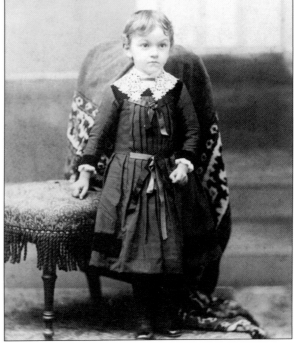

MARY ELSIE HALL. Hall, seen here at age three, was appointed curator when Flora Stilson passed away in 1938. Elsie attended the State Normal-Training School in Danbury and was one of the school's first graduates. She was the daughter of Charles Newton Hall, who was the secretary of the 1907 bicentennial committee.

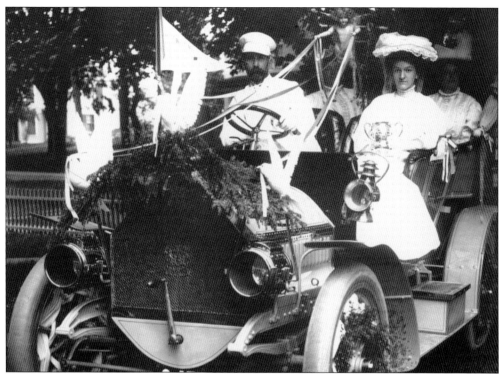

1907 BICENTENNIAL DECORATED AUTO PARADE. Shown here are, from left to right, (front seat) Henry D. Hine and Elsie Hall; (backseat) Mrs. Henry Hine and Mrs. Wm. Watts. Elsie Hall and her parents were very much involved in the town's bicentennial committee and Charles wrote a chapter for the commemorative book *Two Centuries of New Milford, Connecticut: 1707–1907*. Henry Hines's 1907 Berkshire car won first place in the parade. (Courtesy of H.H. Peck.)

KNAPP HOUSE. In the late 18th and early 19th centuries, after loading up supplies from Elijah Boardman's store on Main Street, travelers heading north and west on the Albany turnpike (foreground) could just about extend their hands and say farewell to the occupants of 6 Aspetuck Avenue. The building was given to the historical society by Mary Clissold Knapp in 1955.

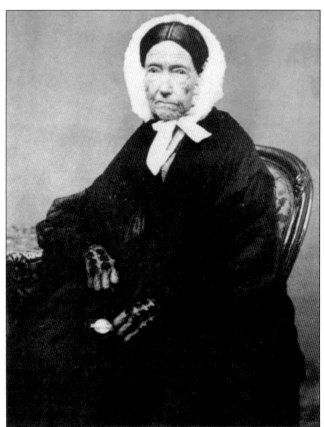

MARGARET L. "LIZZIE MARGARET" KNAPP. In 1838, Lizzie Knapp's grandfather, Levi S. Knapp, sold his shoe shop on Bennitt Street in New Milford to Royal Davis, and Levi's wife, Eliza Roberts Knapp, purchased Davis's homestead north of the green. Lizzie and her family lived in Hartford and spent their summers in the New Milford house.

MARY CLISSOLD KNAPP AND HER KINDERGARTEN CLASS. "Miss Cliss" taught school in Hartford, where she lived most of the year. Her sister Lizzie died 10 years before Mary passed away in 1956, supposedly ending their close relationship. However, after Lizzie's death, Mary often remarked to others that she had conversed with her sister about an important matter just that day.

FREDERICK KNAPP. Frederick was the son of Levi S. and Eliza (Roberts) Knapp. He was born in 1826 and married Mary Eunice Burritt of Roxbury, Connecticut, in 1848. His daughters were Margaret L. and Mary Clissold Knapp. His brother Gerardus Knapp took over Levi's shoe business, while Frederick was a wholesale tobacco dealer and accountant.

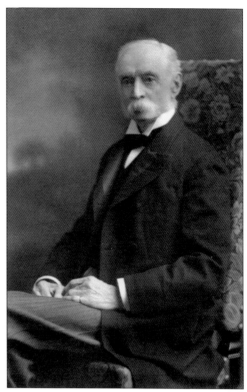

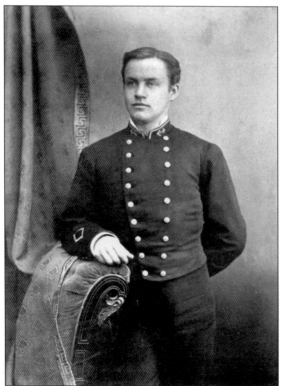

HARRY SHEPARD KNAPP. Frederick Knapp was also the father of Rear Adm. Harry S. Knapp. Harry was born in New Britain in 1856. He graduated from the Naval Academy in 1878 and rose from midshipman in 1880 to rear admiral by 1916. His ship took Pres. William Howard Taft to the Panama Canal, and he was with Pres. Woodrow Wilson at Versailles. Harry Knapp died in Hartford on April 6, 1923.

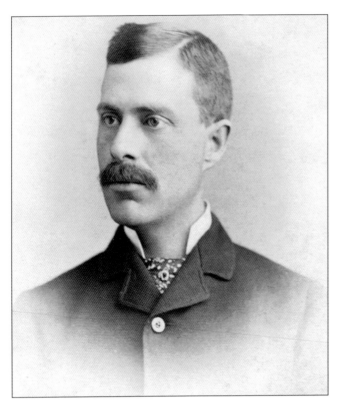

CHARLES MERRITT BEACH.
When Charles M. Beach
became the first president of
the New Milford Historical
Society in 1915, the business
that his father Merritt
Beach started in 1857 was
incorporated as the C.M.
Beach Company. Both entities
are still in existence today
and involve the same family.

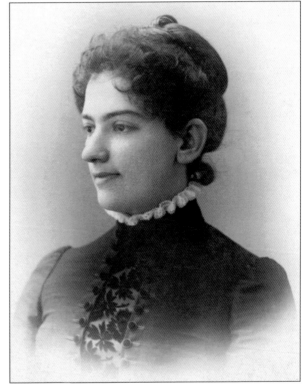

**INA JULIETTE (BUCKINGHAM)
BEACH.** Ina Buckingham was
the daughter of Ralph and Elvira
(Wheaton) Buckingham, She
was born in New Milford on July
24, 1861, and married Charles
M. Beach on October 4, 1890, at
St. Andrew's Church in nearby
Marbledale, Connecticut. She
was a founding member of the
historical society. After her husband
died, she became president of
the C.M. Beach Company.

CANFIELD AND BEACH. This firm had the first lumberyard in New Milford. First located on Elm Street, the company also had a sawmill and advertised "a good quality of family flour at the lowest market price." In a few years, the business, which began in 1857, removed to Bridge Street; in 1875, the building that exists today at 30 Bridge Street was constructed.

NEW LUMBER YARD!

THE SUBSCRIBERS HAVE ENTERED INTO THE

LUMBER BUSINESS

IN THE VILLAGE OF

NEW MILFORD,

At the Steam Saw Mill Place, two doors east of the Methodist Church, and intend to keep a good assortment of

PINE, SPRUCE,

AND OTHER KINDS OF

LUMBER.

Clear, Second Clear, and Merchantable Lumber, both dressed and undressed; Boards from 1-2 inch to 1 inch in thickness. Plank 1 1-4 1 1-2, 2 and 3 inches in thickness; also Sheathing planed and matched, Pine and Spruce Flooring planed and matched. Siding, Shingles, sawed and rived; also Lath. We will exchange, at fair rates, Pine Lumber for Oak and Chestnut Boards, Timber and Fence Posts.

WE ALSO OFFER AND PURPOSE TO KEEP A GOOD QUALITY OF

FAMILY FLOUR AT THE LOWEST MARKET PRICE.

Our Stock has been selected with care, and purchased with cash, and we pledge ourselves to sell the same as low as can be purchased at any Yard in the State, with the exception of additional freight.

It is our intention to keep a good assortment of goods in our line of trade, constantly on hand, and to offer every inducement to secure the patronage of the public. **A. N. CANFIELD,**

New Milford, Nov. 1, 1858. **MERRITT BEACH.**

POMEROY & MORSE'S Cheap Steam Press, corner Wall and Water Streets, Bridgeport.

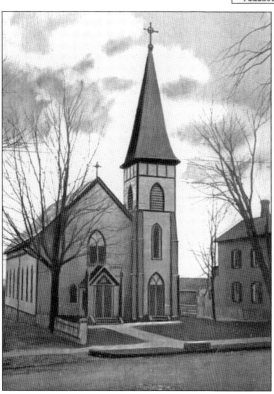

ST. FRANCIS XAVIER CHURCH. No photograph exists of Merritt Beach's business on Elm Street. St. Francis Xavier Roman Catholic Church was at the Elm Street location in 1861, adapting the property for the new parish. In 1871, the sawmill was replaced with a church. St. Francis dedicated a new church on Chestnut Land Road 100 years later. The property on Elm Street is now owned by New Milford Hospital. A marker for the church sits near the entrance to a parking lot.

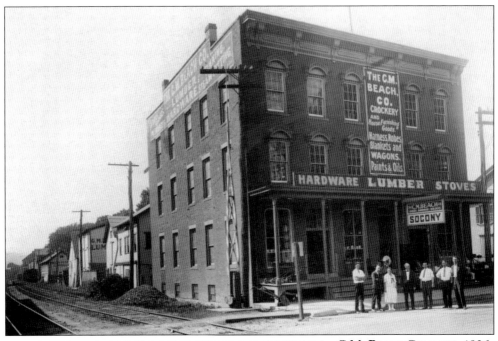

C.M. BEACH COMPANY, 1926. Conveniently located near the train tracks and across from the railroad station, the C.M. Beach store, at 30 Bridge Street, was also one of the first businesses travelers encountered as they entered the town from the bridge at Route 7. In the 1950s, the store featured a General Electric kitchen and a comfortable place to sit and browse through brochures featuring appliances and home improvement. (Courtesy of Russell V. Carlson.)

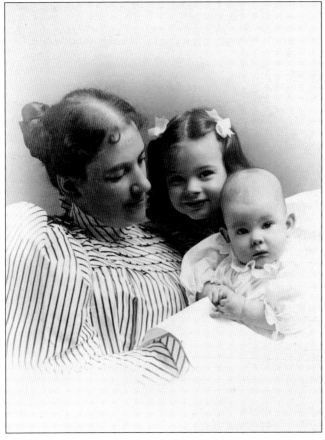

BEACH GIRLS. Ina Juliette Buckingham Beach poses here with her daughters Juliette Buckingham Beach Barker (center) and Marian Beach Barlow. With the passing of Ina's husband, Charles Merritt Beach, Ina and her daughters gained ownership of the C.M. Beach Company.

HERBERT WOODWARD BARLOW.
Barlow was president of the New
Milford Historical Society from
1954 until his death in 1973.
He married Marian Beach on
June 14, 1924, and he managed
his father-in-law's business upon
Charles M. Beach's death. Herbert
was made president of the C.M.
Beach Company in 1957. He was
born on December 11, 1886, in
Meriden, Connecticut, to Albert
L. and Theresa (Disch) Barlow.

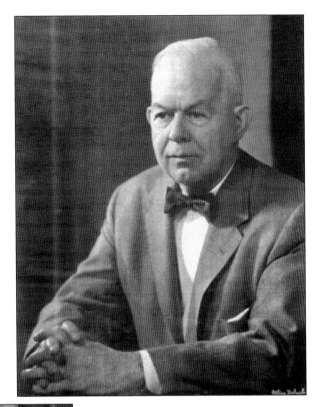

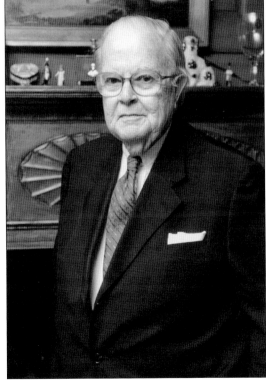

CHARLES BEACH BARLOW. Charlie is a
past president of the historical society
and current first vice president. The
son of Herbert W. and Marian (Beach)
Barlow, Charlie became president of
the C.M. Beach Company in 1973, now
a financial holding company. He also
owns a company he founded in 1982,
Taylor Investment Management, Inc.

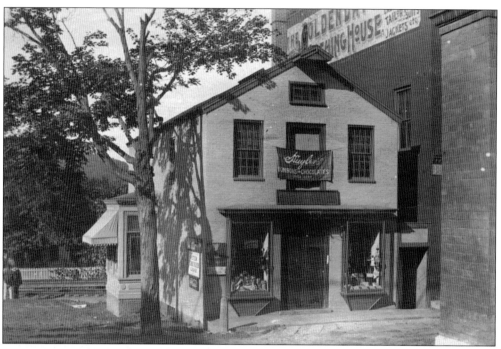

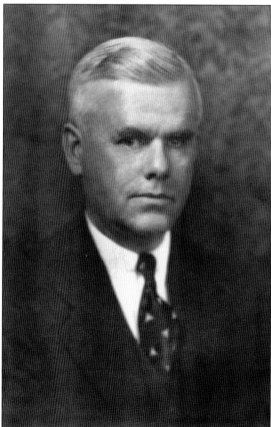

FREDERICK BOARDMAN'S DRUGSTORE. Frederick Boardman had an apothecary on Railroad Street beginning in 1841. He sold the business to Charles Botsford who in turn sold it to Albert Evitts, the historical society's president from 1936 to 1952. Evitts Pharmacy moved to the corner of Railroad and Bank Streets in the early 1900s. Ironically, it was Evitts who saved the doorway on the Bank Street side of the former United States Hotel in 1927, where his competitor, Park Pharmacy, was located. Today, the doorway can be seen at 6 Aspetuck Avenue at the New Milford Historical Society.

ROLAND FAXON MYGATT. Although Mygatt served as president of the historical society for only two years, his family's involvement began with the inception of the organization in 1915. His parents, Henry S. and Nancy (Faxon) Mygatt, were charter members. Following his great-grandfather Eli Mygatt, Roland was president of the New Milford Savings Bank. Roland's wife, Helen Hunt Mygatt, was also a trustee of the historical society.

HENRY SEYMOUR MYGATT. Henry, father of Roland, was the son of Sen. Andrew Burr and Caroline (Canfield) Mygatt. He was born on August 30, 1847, and died on November 16, 1930. His interest in the history of New Milford was evident when he was appointed chairman and president of New Milford's bicentennial committee in 1906.

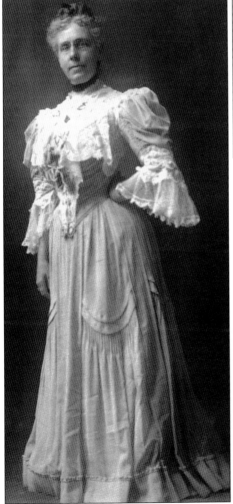

NANCY EELLS (FAXON) MYGATT. Nancy Faxon married Henry S. Mygatt on November 9, 1879. Nancy was one of the founding members of the Roger Sherman chapter of the Daughters of the American Revolution and its first regent. Her participation in the bicentennial celebration included membership on the executive and vocal music committees, as well as providing over 10 items for the artifacts exhibit, including wood from Roger Sherman's house in New Milford.

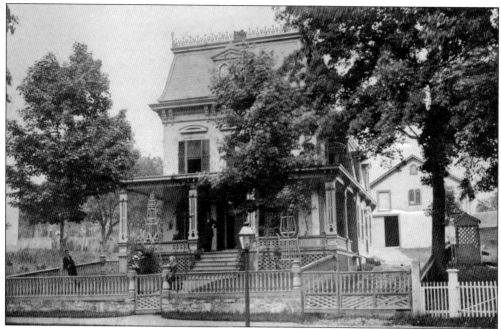

42 Main Street, c. 1885. Henry O. Warner owned this house at the time of this photograph. Warner made sweeping alterations to the 1825 home (built for Lawrence Taylor), including the addition of the Mansard roof. The home was in the Henry S. Mygatt family from 1924 to 1977. Geron Nursing and the law offices of Rebecca Mayo Goodrich occupy the building today.

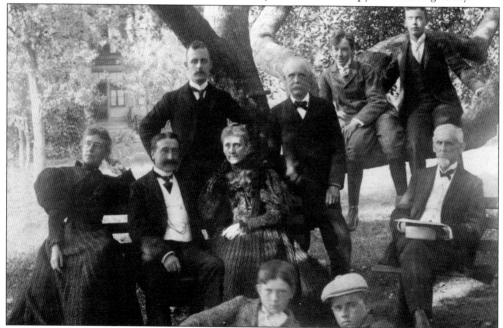

A.B. Mygatt's Orchard at South Main and Bridge Streets. Posing here in the backyard are, from left to right, (first row) Frank A. ? and Roland Mygatt; (second row) Nan Mygatt, Mr. Andrews, Aunt Corrie ?, and A.B. Mygatt; (third row) Fred ? and Henry S. Mygatt; (fourth row, in tree) Harry Andrews and Andrew Mygatt.

RICHARD MOREHOUSE BOOTH.
President of the New Milford
Historical Society from 1973 to
1978, Booth was born in New
Milford to Noble Bennitt and
Flora (Morehouse) Booth. He
was a music teacher at the South
Kent School for 35 years. Richard
Booth was a generous benefactor
to the historical society; items
he donated can be seen in the
main gallery of the museum.

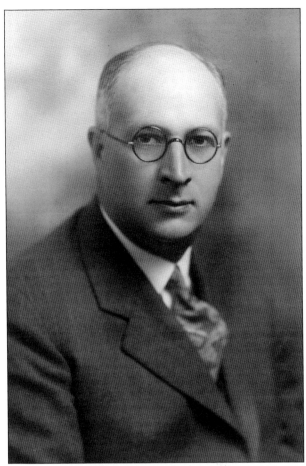

**WEDDING OF FLORA REBECCA
MOREHOUSE AND NOBLE BENNITT
BOOTH.** Flora and Noble (first
row, third and fourth from left)
were married on September 11,
1911, in South Kent, Connecticut.
Noble B. Booth was the son
of Andrew M. Booth; he was
a clerk in the general store of
his brother Reuben. They were
descended from Richard Booth,
who was born in England in 1607.
Richard M. Booth's great-great-
grandfather was Walter Booth.
Walter's home, built in 1812,
still exists at what was previously
11 Grove Street, today Booth
House Lane (Prospect Hill).

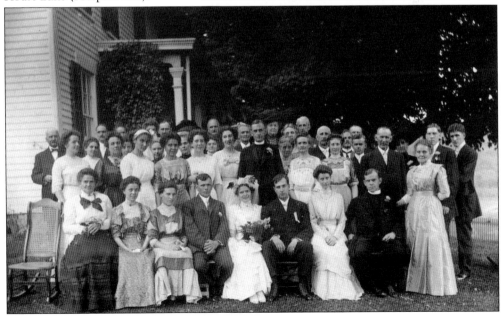

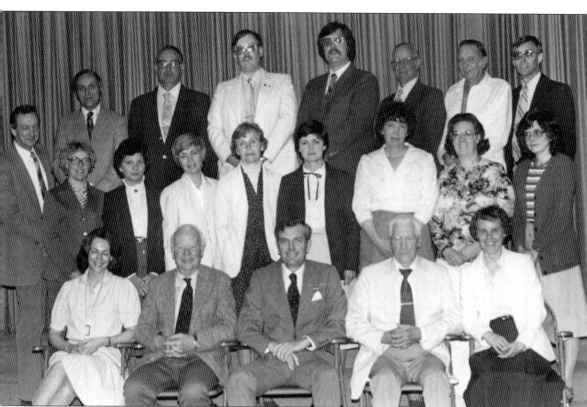

M. JOSEPH LILLIS JR. Lillis was appointed New Milford's town historian in 1988 and was president of the historical society from 1979 to 1981. He was a member of New Milford's 275th anniversary committee. Photographed on May 13, 1982, the committee members are, from left to right, (first row) Leslie C. Sowell, Paul M. Hancock, Lillis, Howard H. Peck, and Sally M. Rinehart; (second row) Janet B. Parsons, Virginia V. Wall, Patricia A. Griffith, Georgia L. Girardo (society curator), Sandra K. Harkness, Joanne S. Pappano, Margaret R. Evans, and Pamela H. Cooper; (third row) Frederick J. Wynne, John J. Bongiorno, Irving A. Armstrong, Lee T. Hendrix, Danny R. Straub, Wilbur F. Webster, Theodore L. Hine, and Arthur W. Putnam. Lillis grew up on the corner of Elm and East Streets. He worked at the Lillis Funeral Home, a business begun in 1928 by his father and that continues today. M. Joseph Lillis Jr.'s license plate was hard to miss: NMCT.

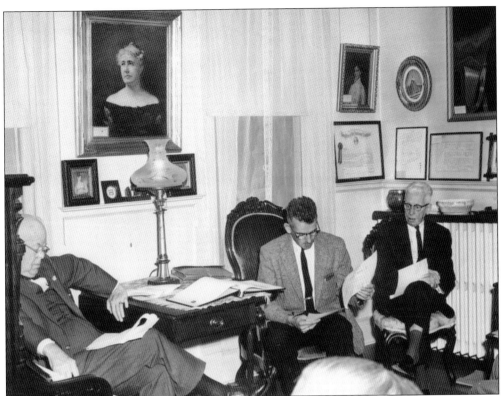

New Milford Historical Society Meeting. Members of the board shown here are, from left to right, Herbert Barlow, Douglas Smyth, and C. Andrew Humeston. This meeting, in October 1963, was probably one of the last held at the historical society on Main Street. The Main Street property was sold to New Milford Savings Bank. On July 22, 1964, the new building at 6 Aspetuck Avenue was opened to the public.

Charles Andrew Humeston. Andrew was the son of Benjamin. F. Humeston, a grocer and liquor retailer. Benjamin built the three-story Humeston Block on Railroad Street. In October 1965, the lower gallery of the New Milford Historical Society was named Humeston Hall in tribute to the Humeston family and for Andrew's 26 years of service as the society's secretary.

B. F. HUMESTON,

——BOTTLER OF——

SODA, SARSAPARILLA,

——AND——

GINGER ALE,

Railroad Street, New Milford, Ct.

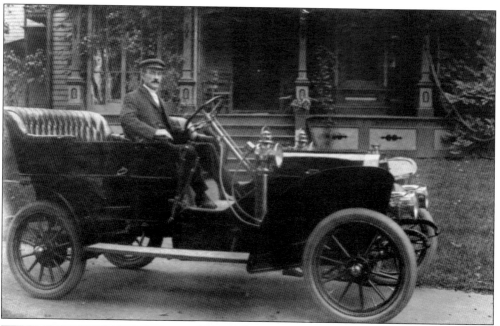

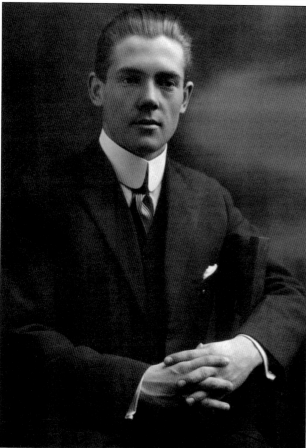

JOSEPH H. NETTLETON. Another charter member of the New Milford Historical Society, Joseph Nettleton displays his 1908 Oldsmobile in front of his mansion on Main Street. Nettleton was born in Bridgewater, Connecticut, on July 24, 1865, the son of Joseph S. and Gertrude A. (Treat) Nettleton.

HOWARD TURNEY NETTLETON, 1914. Howard was the son of Joseph H. and Hattie Alosia (Soule) Nettleton. Howard was married to Ruth C. Roberts. Howard's grandfather, Turney Soule, was a building contractor. The T. Soule & Company granary at 29 West Street was converted into apartments in 2005. Cass and Jim Hancock received preservation awards from the town and state for the restoration. In the 1980s, the Howard Nettleton estate's donation to the historical society equaled that of the Boardman bequest of an endowment, land, and artifacts.

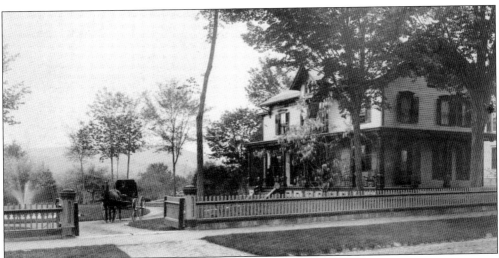

NETTLETON HOMESTEAD ON MAIN STREET. Built for David E. Soule in 1879, this house replaced Judge David S. Boardman's home. At the turn of the 20th century, it was the home of Turney Soule. His neighbor to the south, separated by a fountain and a fenced-in gazebo, was Mrs. Henry E. Bostwick.

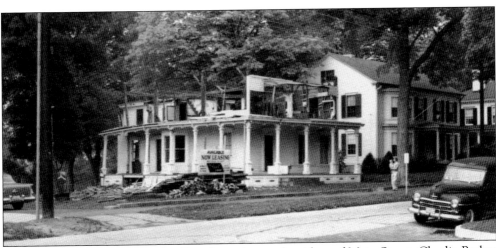

ANOTHER ONE BITES THE DUST. Board member, and resident of Main Street, Charlie Barlow recalls watching homes disappear one by one. On the west side of Main Street, 13 residences vanished in the 1950s and 1960s to make way for stores and banks. The Nettleton homestead was sold in October 1958 to Willimantic Investors, Inc., and replaced by a supermarket.

MARY BAKER AND DANIEL T. WEAVER. Mary B. Weaver was a trustee of the New Milford Historical Society and the first female to represent New Milford in the state legislature. She was born to Vincent Sterling and Jennie Seeley (Baker) Weaver on December 12, 1887, in Washington, Connecticut. Early on, she spent time in Colorado, and her first words were spoken in Spanish. She is shown here next to the horse block on the farm of her stepfather, Andrew G. Barnes. Mary sold the farm to Kimberly-Clark in 1960. (Courtesy of B.W. Street.)

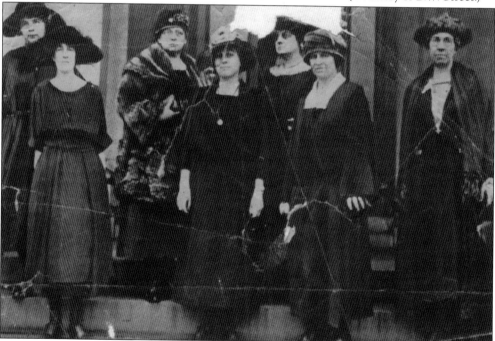

MARY BAKER WEAVER. Weaver is quoted as saying, "If suffrage be a right, then it must not be withheld from women." She is shown here around 1925 with the other female representatives of the Connecticut Legislature. They are, from left to right, (first row) Lillian Frink, Elizabeth Green, Helen Lewis, and Marie Emmons; (second row) Mary Weaver, Annie Vinton, and Clarissa Nevius. Weaver was one of the few female members of the Connecticut Tobacco Growers Cooperative. She was also a schoolteacher and ran the farm of her stepfather, Andrew Barnes, after he passed away. (Courtesy of B.W. Street.)

GREEN WAREHOUSE. Decked out in bunting for New Milford's bicentennial, this warehouse was built by William Green (founding member of the New Milford Historical Society) for the storage of Housatonic Valley Havana Seed Type 52. Posing in front of the building are, from left to right, Edgar Hannon, William Green, his sons Sherman D. Green and Van Ness Green, and Gus Rosinko. (Courtesy of Burton Green.)

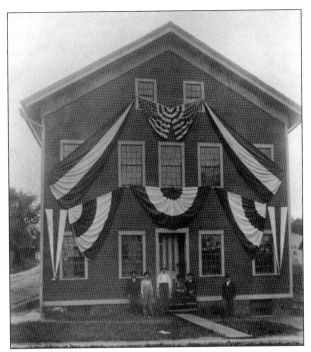

PERRY VAN NESS GREEN. The son of Sherman Green and grandson of William is shown here in 1907, perhaps dressed for the bicentennial. A tobacco broker, Perry later joined the family business at 34 Bridge Street. When the tobacco business was on the wane, Perry's father, Sherman, opened a harness shop in the warehouse.

SHERMAN DUDLEY "UNCLE" GREEN. Sherman was the son of William and father to Perry Van Ness Green. Sherman's career in tobacco started when he was a buyer for his father's business in 1892. On September 20, 1923, residents saw the first airplane to visit New Milford—it was sporting a banner for Uncle Green cigars.

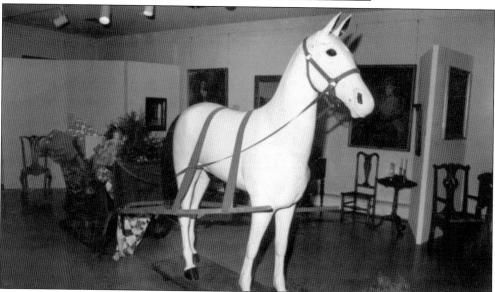

CHRISTMAS CHIEF WARAMAUG, 1986. The famous Green warehouse mascot was donated to the historical society. He is seen here in the main gallery. When Perry Green retired from his business, the chief retired from modeling saddles, harnesses, and lead ropes. Chief Waramaug currently stands guard in the historical society's Boardman store.

Eight

LET'S ALL CELEBRATE

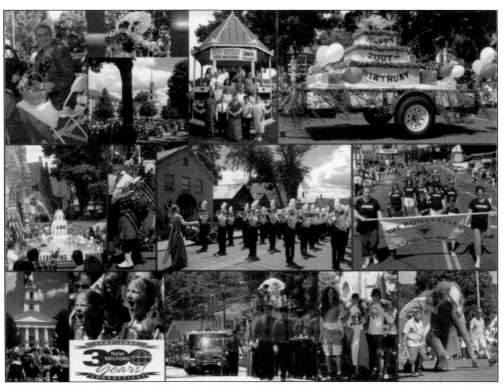

POSTCARD FOR TERCENTENNIAL PARADE. New Milford was 300 years old in 2007, and participants in the celebration pulled out all the stops for the parade on Sunday, July 1. Many activities were planned by chairman of the tercentennial committee Katy Francis, beginning with an ecumenical service at New Milford's first place of worship, the First Congregational Church. Also, a collection of paintings by Woldemar Neufeld was published. His artwork can be seen in the Boardman gallery at the New Milford Historical Society.

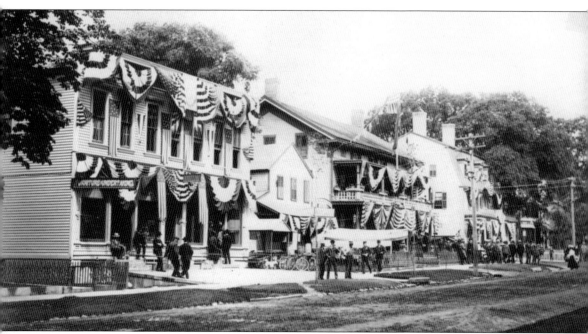

GREAT FIREMAN'S PARADE, 1900. The buildings on the west side of Main Street (between Bridge and Banks Streets) are, from left to right, as follows: a two-story, wooden structure with a YMCA on the second floor and a furniture and undertaking business on the first floor; the US Post Office; James L. McEwan's Meat Shop; the New England House, Isaac Bristol, proprietor; and the United States Hotel on the north side of Bank Street. The parade included 1,300 firefighters. This area was laid out by one of the first 12 settlers in New Milford, Roger Brownson. The first buildings were residences; later, there was a tannery and boot manufactory. In less than two years, the buildings shown here would be nothing more than a memory after the devastating fire of 1902.

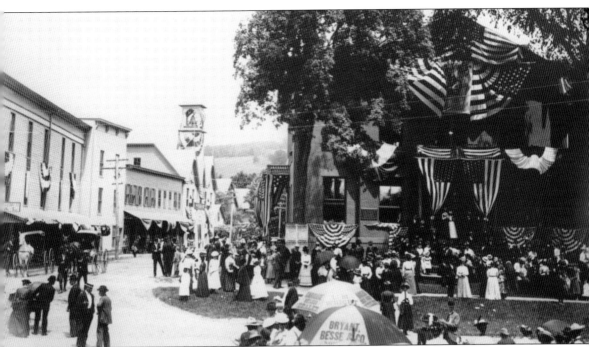

FIREMAN'S PARADE, 1900. The parade is seen at the intersection of Main (east side) and Church Streets. On the right, facing west, is the Roger Sherman Town Hall. The partial building on the left is Staub & Mallett Hardware store (now Village Center for the Arts), and next to that is the Starr building. The hardware store was built in 1837 as the St. John's Episcopal Church. St. John's current edifice was built in 1882. Church Street did not become a thoroughfare until 1876. The structure in the background with the tower is the firehouse of Water Witch Hose Company No. 2 (originally Water Witch Engine Company No. 2), built 10 years before this photograph was taken. The two-ton bell, cast in 1898, which sat in the Church Street tower, has been moved to Grove Street, where the current firehouse is located.

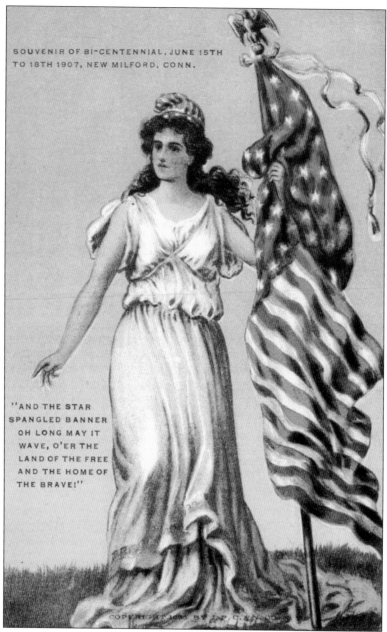

SOUVENIR OF BI-CENTENNIAL, JUNE 15TH
TO 18TH 1907, NEW MILFORD, CONN.

"AND THE STAR
SPANGLED BANNER
OH LONG MAY IT
WAVE, O'ER THE
LAND OF THE FREE
AND THE HOME OF
THE BRAVE!"

BICENTENNIAL POSTCARD. Just five years after the great fire, New Milford had reason to celebrate. The destruction had not stopped the town in its tracks. The rebuilding started the next day; by the time of the bicentennial, streets and drainage had improved, there were new hotels and banks, and the population had increased. In May 1907, approximately 2,000 copies of an official invitation were sent out for the festivities. The six-inch-by-eight-inch invitation (using the same script as that for the invitations to the St. Louis World's Fair) read: "The people of New Milford, Connecticut, cordially invite [blank] to attend the Bi Centennial Celebration of the settlement of their town, Saturday, Sunday, Monday and Tuesday, June 15th, 16th, 17th, and 18th, 1907. Saturday, June 15th, Formal Opening of Celebration, Sunday June 16th, Thanksgiving services in all the churches. Monday June 17, Historical Addresses. Tuesday June 18th, Parades and Fireworks."

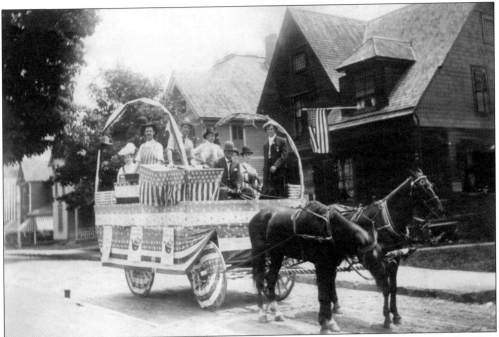

NEW MILFORD HAT COMPANY. Although Danbury "crowned them all," hats were produced in New Milford beginning in 1855 with the Smith & Irwin Company. The New Milford Hat Company, begun by J.E. Bates and S.S. Green in 1881, had an extensive factory on Housatonic Avenue in New Milford. The company's bicentennial float is seen near Dr. James C. Barker's home on Whittlesey Avenue. Alonzo Couch has the reins.

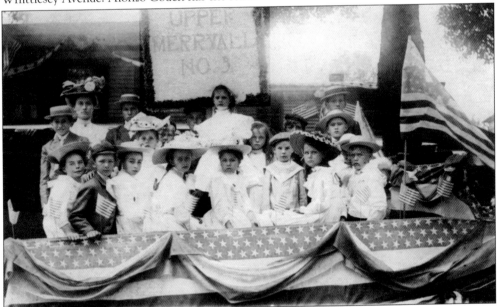

UPPER MERRYALL NO. 5. Decked out in red, white, and blue, 22 schoolchildren, some not visible here, rode in the Upper Merryall District parade float. The hour-and-a-half procession with 5,000 onlookers began on time, as did every event of the four-day spectacle. According to the local newspaper, it was one of the "prettiest parades ever witnessed in western New England."

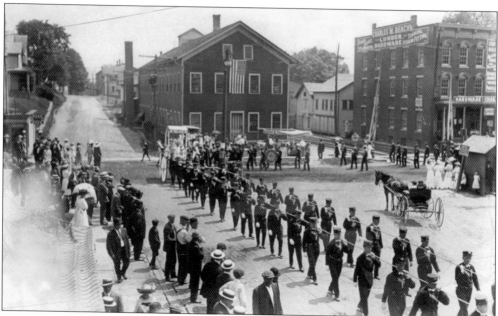

1913 FIREMAN'S PARADE. This procession advances east on Bridge Street, past the C.M. Beach building. It will then turn left and head north onto Railroad Street at the Green warehouse. The 10-year-old parade carriage can be seen in the distance in front of Green's. Water Witch Hose Company No. 2 purchased its first automotive engine in 1916.

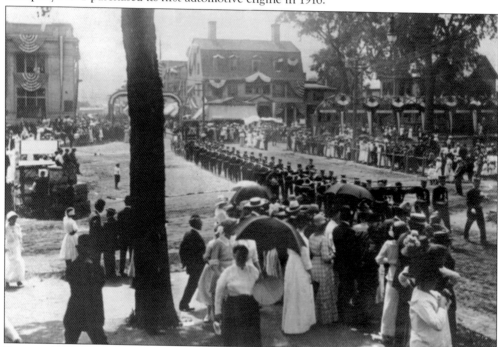

FIREMAN'S PARADE CONTINUES. The procession continued up Bank Street and is seen here heading east toward the firehouse on Church Street. The Green's water trough, left of the tree, makes a nice viewing stand. In the distance are the United Bank Building (left) and the United States Hotel.

1945 Decoration Day Parade. This flivver leads a contingent of automobiles down the west side of Main Street, past the Park Pharmacy at the corner of Bank Street. In the New Milford Historical Society's collection is a large portrait of John Logan. Logan fought in the Civil War, and, in 1868, as commander in chief of the Grand Army of the Republic, he ordered that every GAR post should hold suitable exercises to honor dead comrades and to decorate the graves of the deceased with flowers and flags as living memorials. A century after the first Decoration Day, the holiday was moved from May 30 to the last Monday in May. The previous year, 1967, it was renamed Memorial Day. Logan is quoted as saying, "Let not ravage of time testify to coming generations that we have forgotten, as a people, the cost of a free and undivided republic."

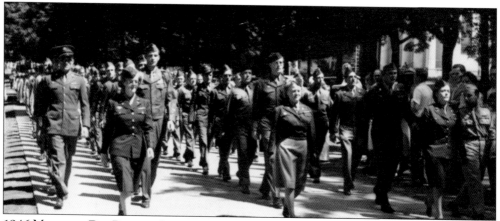

1946 MEMORIAL DAY PARADE. Servicemen and servicewomen march up Bridge Street representing World War II veterans. Until World War I, Memorial Day honored only those who died in the Civil War. The event was commonly known as Memorial Day even though the name did not become official until 1967. In 1968, Congress enacted the Uniform Monday Holiday Act.

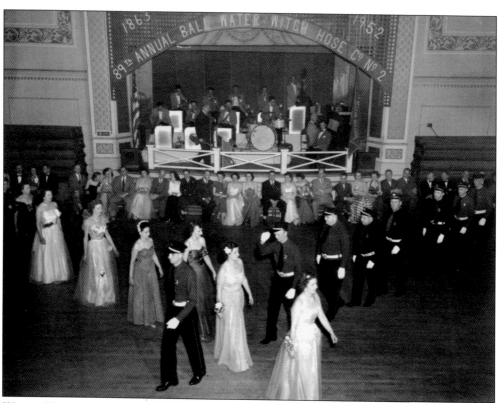

WATER WITCH HOSE COMPANY NO. 2, 1952. Described as the social event of the year, the Annual Ball was usually held on the second floor of the Roger Sherman Memorial Town Hall on Main Street. The first ball was in 1863. Water Witch's predecessor was the New Milford Fire Company, chartered in 1830. Anan Hine was the foreman. Shown here is the parade at the 89th Annual Ball.

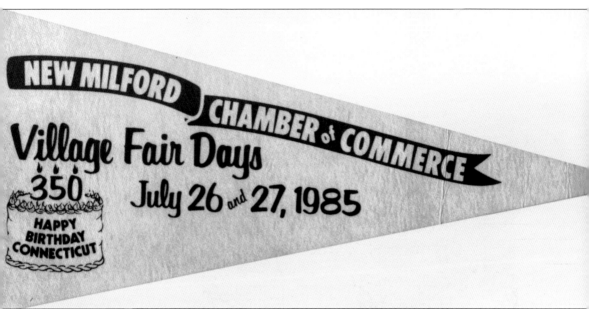

VILLAGE FAIR DAYS. The largest event in New Milford has always attracted people from all over the Northeast. It is sponsored by the Greater New Milford Chamber of Commerce. Volunteers labor all year to make this two-day celebration on the green an entertaining and exciting event. It provides a venue for artists, craftspeople, food vendors from organizations and nearby restaurants, and antique dealers. It also includes booths sponsored by churches, civic organizations, nonprofit associations, and businesses. Groups perform throughout the day, and walking tours of historic downtown buildings are available. The probate judge of the Housatonic District, Marty Landgrebe, usually hosts a tour of the Roger Sherman Memorial Town Hall. The opening of the fair commences with the singing of the national anthem, a ribbon cutting, the crowning of the Village Fair Days' king and queen, and it finishes with speeches and the presentation of awards. Proceeds from the fair go to a scholarship fund.

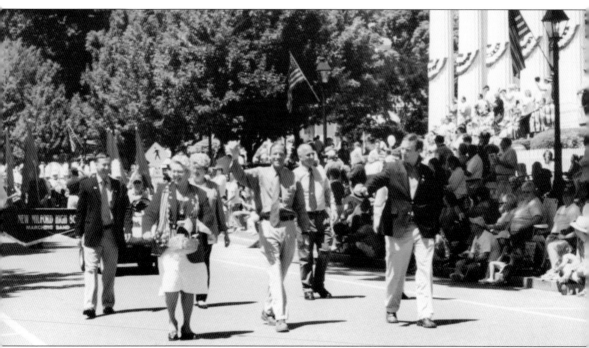

New Milford's Tercentennial Parade, July 1, 2007. Politicians on the march are, from left to right, (first row) New Milford mayor Pat Murphy, state attorney general Richard Blumenthal, and US representative Chris Murphy; (second row) state senator David Cappiello, state representative Mary Ann Carson, and state representative Clark Chapin. The color scheme of the day was, of course, green and white, and the theme was "Time to Remember." It took two years to prepare. Chairman Katy Francis asked the community for input for the defining event of the 300-year celebration. Floats included those for organizations and clubs and tributes to founding families. The parade featured the Winona Steam Calliope, the Governor's Horse Guard, and a collection of Corvettes. The tercentennial celebration concluded on December 31, 2007, with a ceremony at the First Congregational Church and a fireworks display over Still Meadow. On May 17, 2008, a time capsule of 94 items from 2007 (including a portable DVD player) was buried on the grounds of the New Milford Historical Society.

Nine

THE GREEN

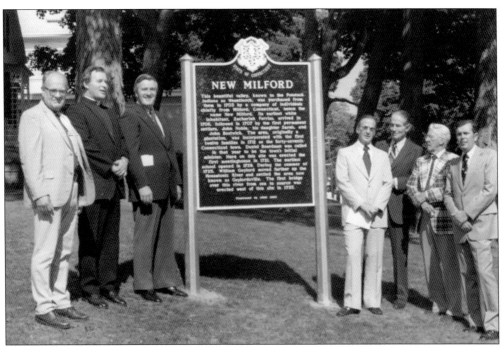

DEDICATION OF HISTORICAL MARKER. To commemorate the nation's bicentennial, a marker displaying a synopsis of New Milford's history was dedicated on June 27, 1976, next to the historical society. Howard Peck, the former town clerk, is at far right. M. Joseph Lillis Jr., chairman of the bicentennial committee, is second from right. The other persons are not identified. Lillis remarked, "New Milford . . . has been a living community—a place of farms and factories, a home for tradesmen, fishermen, merchants, and educators."

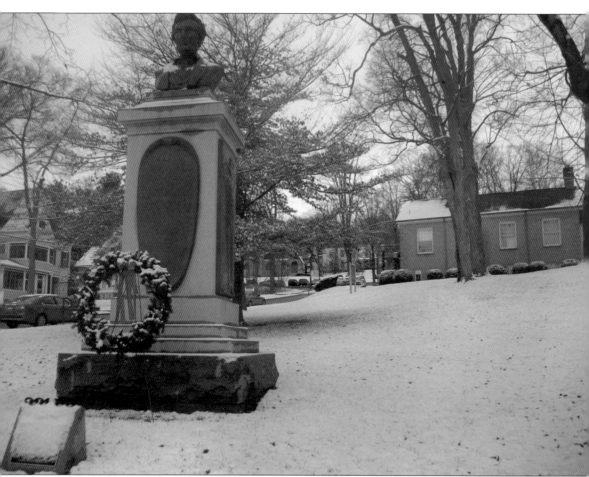

LINCOLN MEMORIAL. Below the bicentennial historical marker, Abraham Lincoln has a bird's-eye view of New Milford's Green. Behind him is the New Milford Historical Society. The monument was a gift of Edward Williams Marsh, who served in the Civil War. He was a captain of Company M, 2nd Connecticut Volunteers, Heavy Artillery. The rest of the north plaque reads: "To the Town of New Milford / In Loving Memory of the Soldiers and Sailors / Of the Union Army and Navy / 1861–1865 / and of / Abraham Lincoln / President of the United States / 1861–1865 / Besides being in many skirmishes the New / Milford troops were engaged in the battles of / Gettysburg / Cold Harbor / Petersburg Opequan (Third Winchester) / Fisher's Hill / Cedar Creek / Sailors Creek / Fort Fisher." The plaque on the monument facing south quotes Lincoln's "Gettysburg Address." The 12-foot-high pedestal of Vermont granite and the four-foot bronze bust were designed by Paul Winters Morris and dedicated on May 30, 1912.

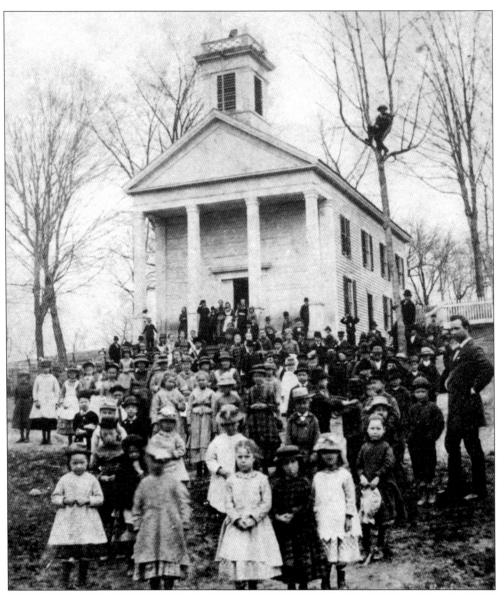

NEW MILFORD PUBLIC SCHOOL, C. 1870. Instead of going to the head of the class, apparently, someone considered himself above the rest. Before the Lincoln herm was erected, this was the site of a town meetinghouse used for religious services, public meetings, and education. The first building here was constructed in 1729. The building seen here was constructed in 1845 by John Mallett. It replaced a school that had been in operation since 1787. In 1876, a new school (Center School) was built on East Street, and the bell from the old school was installed there, but no one seems to know where the rest of the structure, which was purchased by several individuals, ended up. Today, 50 East Street (formerly the New Milford High School) is the site of the school district's offices and youth agency. The structure, the Catherine E. Lillis Administration Building, is named after a former teacher and school administrator.

ALBANY TURN PIKE MILEAGE MARKER. This stone probably replaced an earlier one that had been required by a Connecticut law. The statute called for two-foot milestones to be placed by selectmen at primary routes. The turnpike was used to deliver mail. The marker is at the bottom of what is now called the Old Albany Post Road.

REVERSE SIDE OF MARKER. In the background are the crosswalks at the intersection of Main Street (east side) and Elm Street, and at the bottom of the Albany Post Road. Today, the road runs between the New Milford Historic Society and St. Francis Xavier Parish Center. The stone was installed in 1957 by the New Milford Historical Society's president, Herbert W. Barlow.

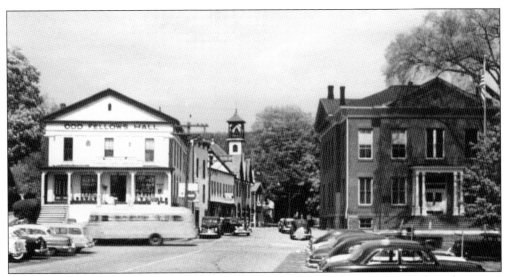

INTERSECTION OF MAIN AND CHURCH STREETS. Not long after this photograph was taken, the portico was removed from the Roger Sherman Memorial Town Hall (right) in 1960. In 1965, an annex was built onto the rear of the building and dedicated to "Mr. New Milford," Howard H. Peck.

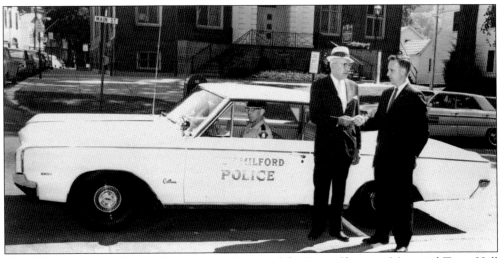

NEW MILFORD POLICE SQUAD CAR. A partial view of the Roger Sherman Memorial Town Hall shows the new Neo-Georgian entrance. New Milford's two lockup cells (jail) were located in the basement at the town hall. When the annex was built in 1965, the police department occupied its first floor. The police station at 49 Poplar Street was built in 1989.

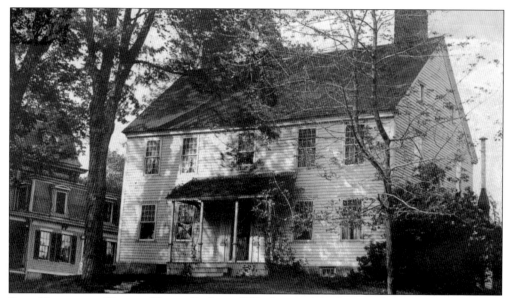

Rev. Nathaniel Taylor Home. Built in 1759, this was the home of New Milford's second Congregational minister. In 1749, Reverend Taylor married Tamar Boardman, the daughter of the first Congregational minister, Rev. Daniel Boardman. Taylor was born in Danbury, and he and Phineas Taylor "P.T." Barnum are descended from one of its first settlers, Thomas Taylor. The partial building on the left in the above photograph was built for Lawrence Taylor, the reverend's grandson. Another grandson, George Taylor, lived just north of Lawrence. Lawrence and George were the sons of Col. William Taylor. The dwelling the reverend had built for his son Col. Nathaniel Taylor in 1774 still stands at 34 Main Street and is occupied by Charles and Eloisa Barlow. Reverend Taylor's residence was demolished around 1910 (below) to make way for the Main Street School. It is said that timbers from Taylor's home were used to construct the building at 32 Taylor Street.

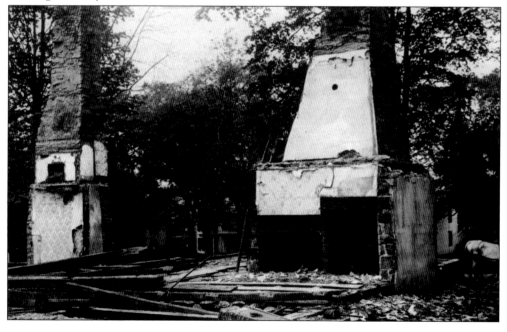

NEW MILFORD HIGH SCHOOL. Known today as the Richmond Center, 40 Main Street was built as the New Milford High School around 1910. In 1931, a new high school was built on East Street, and this building became the Main Street School for elementary students. It was renovated in 1984, and in June of that year, the Paul S. Richmond Citizen Center was dedicated. Today, it houses the New Milford Senior Center, Wheels Program of Greater New Milford, Red Cross, and other social services.

PAUL SEELEY RICHMOND. Richmond (left) was chairman of the Main Street School renovation committee. He was born on December 23, 1902, the son of William L. and Kate (Bowers) Richmond. In 1947, he started the Paul S. Richmond Insurance Agency. He was a 52-year member of the Water Witch Hose Company No. 2. The Richmond family has donated several artifacts to the historical society.

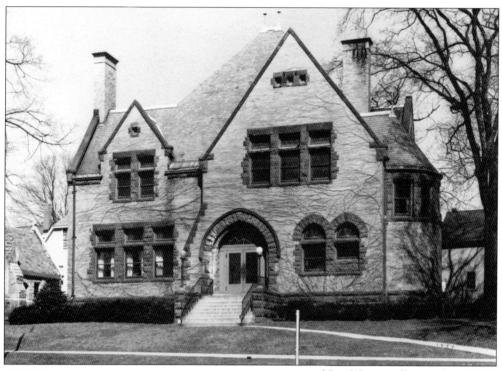

NEW MILFORD PUBLIC LIBRARY AND MEMORIAL HALL, 1957. In 1796, 60 subscribers paid $3 to become shareholders of the Union Library. On June 10, 1893, the town passed a resolution to "build, erect and maintain a Memorial Hall and Library Building, to be suitable for use as a Public Library and to be used for the meetings of the Grand Army of the Republic." (Courtesy of Howard H. Peck.)

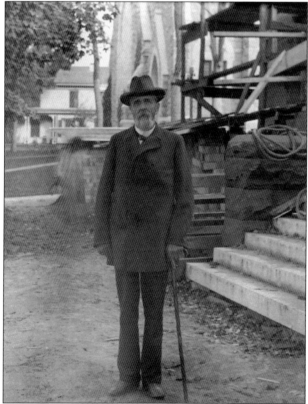

EGBERT MARSH. Marsh donated funds, offered land, and left a trust for the purchase of books and other materials for the public library and memorial hall. He was born on May 22, 1830, and died one year before the library opened in 1897. He lived across the street from the library. (Photograph by J.H. Nettleton.)

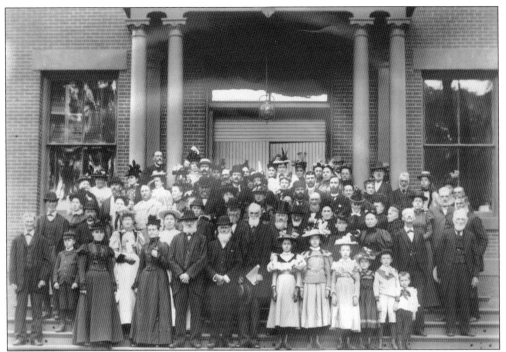

MARSH FAMILY REUNION. The Marsh clan gathered for a photograph in 1884. No one is identified, but no doubt, Egbert is included, as is his cousin Edward Williams Marsh, who emulated Egbert when he donated the Lincoln memorial in 1912. A distant cousin, Charles H. Marsh, was a Civil War Medal of Honor recipient. Egbert married Helen C. Canfield, the daughter of Col. Samuel and Rebecca Maria (Taylor) Canfield.

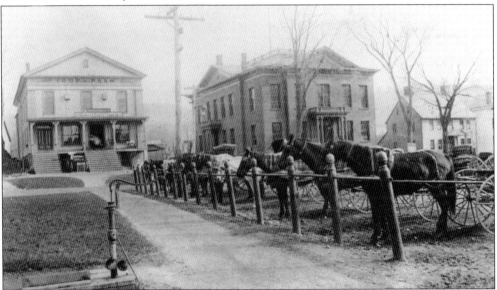

THE GREEN LOOKING EAST, C. 1900. The Marsh family was probably photographed in front of the Roger Sherman Memorial Town Hall. The buildings seen here are, from left to right, the Staub & Mallett hardware store, the town hall, and the Noadiah Mygatt home. At left, in the foreground, is a public drinking fixture with tin cups attached.

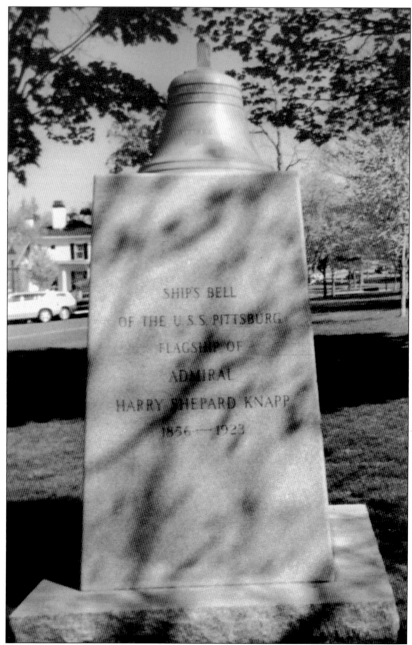

Bell of the USS *Pittsburgh.* Located in the middle of the green near Whittlesey Avenue, this tribute to Rear Adm. Harry Shepard Knapp was erected in 1951 by the American Legion Ezra Woods Post No. 31. Knapp assumed command of the cruiser *Charleston* in 1908 and the *Tennessee* in 1910 and was the first in charge of the USS *Florida* in 1911. Just before World War I, he was appointed rear admiral. From 1916 to 1918, Knapp was military governor of Santo Domingo. He received medals of honor from the French government and the Order of the British Empire. Knapp spent summers at the ancestral home in New Milford, and the bell from his flagship was given to Harry's sisters, Lizzie and Mary Clissold Knapp, but was kept in storage at the C.M. Beach Company until 1951. Knapp died in Hartford on April 6, 1923.

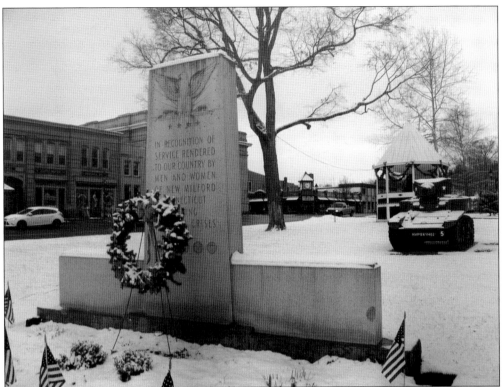

NEW MILFORD VETERANS MONUMENT AND TANK ON THE GREEN. The all-war memorial (above) is located at the southern end of the green at Bridge Street. In between the eagle and emblems for branches of service are the following words: "In Recognition of / Service Rendered / To Our Country by / Men and Women / Of New Milford / Connecticut / During / National Crises." The military jungle gym behind the monument is from World War II, but it was produced too late to be put in service. Across Bridge Street in front of the Lillis Funeral Home near the road is a plaque at the base of a flagpole with names of those who died in World War II. The residence shown below on Main Street was the home of Charles N. Robertson, who purchased the M-3 tank. The vehicle was stored at Robertson's Bleachery on West Street. The mobile monument to World War II veterans was placed on the green on July, 4, 1948. Countless numbers of children have enjoyed the tank over the years—except the one who got stuck there a few years back. (Above, courtesy of Hilary McKenna.)

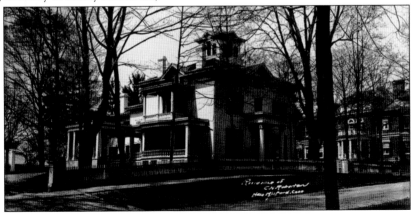

ROGER SHERMAN MEMORIAL TOWN HALL. The Village Improvement Society was founded in 1871. It was the goal of the organization to clean up the green and contain water pollution. The following year, the watercourse that flowed through the green expanse was paved over. In 1875, a bandstand was constructed to accommodate the town's cornet band. That same year, Town Hall was erected, replacing two dwellings at this site.

HEACOCK BROTHERS ADVERTISEMENT. Town Hall, the First Congregational Church, the *Gazette* newspaper office on Bridge Street, Mrs. Wright's walk on Railroad Street, and the Treadwell place on Elm Street are some of the places where the Heacocks paved concrete. Members of the family were also engaged in hair cutting, operating a bowling alley, music, fishing, and farming.

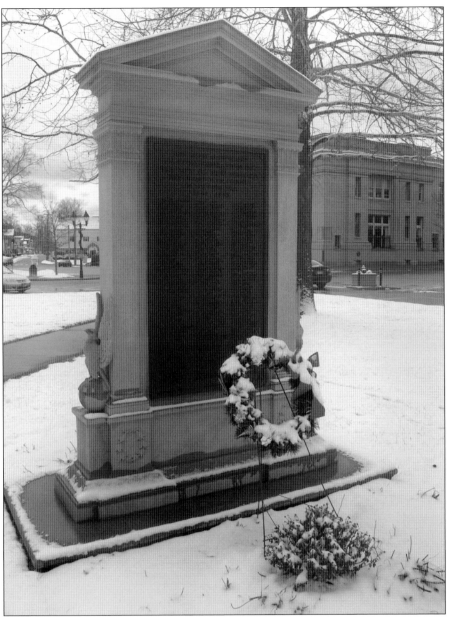

CIVIL WAR MONUMENT. This war memorial, with names of Civil War and World War I veterans, was erected on the green in 1920. Richard Heacock, the first member of the family to come to New Milford, as early as 1840, from New York, has his name on the Civil War side. Richard was a member of Connecticut's 29th Colored Regiment Volunteer Infantry. The name of his grandson Roland T. Heacock is on the reverse side. Roland's father, Rev. Stephen Heacock, established the Advent Christian Mission in New Milford. He was ordained in 1897; four years later, his church on Broadside Avenue was dedicated. The building became a theater in 1973 and is now home to TheatreWorks. Roland was schooled at Howard University, Yale Divinity School, and Boston University. He pastored at black and white Congregational churches. In the 1950s, he was featured in *Time* and *Look* magazines, and in 1965, he wrote *The Negro Protest*. Roland also served in World War II.

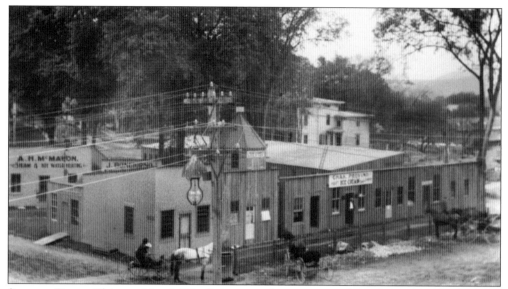

SHANTY TOWN. This was New Milford's business district, created on the green right after the great fire. The building at far left is Albert H. McMahon, heating contractor. Next to it, behind the building at left foreground, is John Bongiorno's shoe and boot repair. The long building at right is Charles Provino's fruit and ice-cream establishment. The enclosed bandstand (center) served as a barbershop.

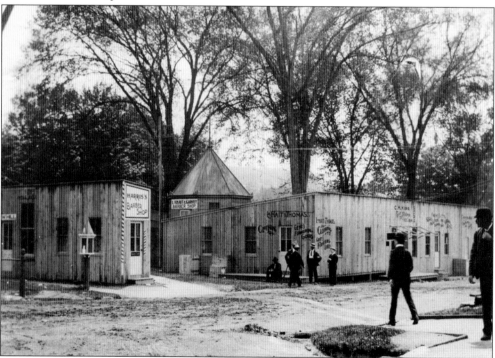

SHANTY TOWN. Here, a building is missing from the previous photograph, where the paved walkway is exposed. On the left, Merritt W. Hill, jeweler, shares a building with Henry C. Harriss, who seemed to be competing for haircuts with LaHait and Garvey in the bandstand. Carl Hipp's name is on the fruit and ice-cream shop.

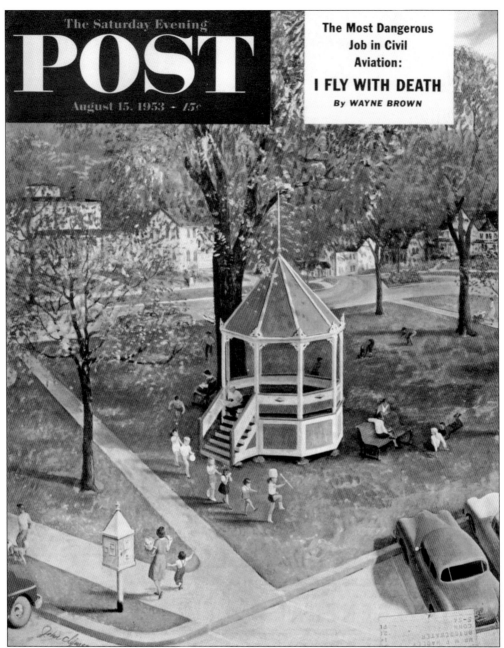

The Saturday Evening
POST
August 15, 1953 - 15¢

The Most Dangerous
Job in Civil
Aviation:
I FLY WITH DEATH
By WAYNE BROWN

AMERICAN BANDSTAND. John Clymer created this cover of the *Saturday Evening Post*, featuring New Milford's bandstand on the green. During the American bicentennial year, a special concert was held here on June 13, 1976. The New Milford High School band paid tribute to the first director of the band, Harold Ives Hunt. New Milford's "Mr. Music" was born on April 12, 1893. For over 40 years, he was a music teacher and supervisor in local schools and choir director and organist of the First Congregational Church. Hunt conducted Friday evening concerts here for many years. He died on August 21, 1974. Just before the bicentennial concert, the New Milford Rotary Club restored the structure. In 1988, however, the bandstand refused to yield the right-of-way to an automobile. The bandstand had to be dismantled and restored yet again.

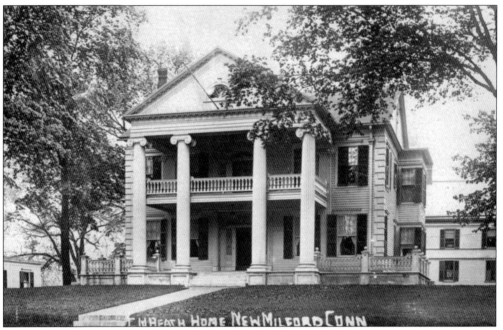

ITHAMAR CANFIELD HOME. Now the site of the Lillis Funeral Home, this structure at 58 Bridge Street was built in 1824 as the residence of Ithamar Canfield's son Royal Canfield. Later a boardinghouse, it was redesigned for Charles Merritt Beach in 1910–1912. Beach's family resided here until 1961.

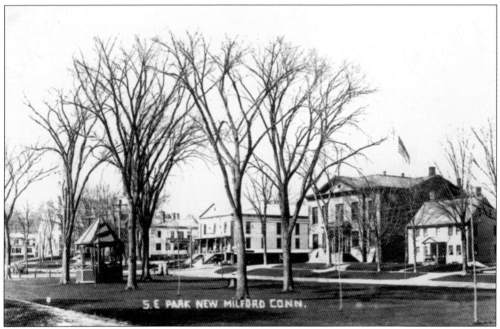

THE GREEN, LOOKING NORTH. A good vantage point from which to view the green is at 58 Bridge Street. This photograph was probably taken near the intersection of Main and Bridge Streets in the early 1900s. The village green is a part of Main Street, New Milford's first highway, laid out in 1713.

THE WATERING TROUGH. In 1906, a water trough was added to the village green, across from the Roger Sherman Memorial Town Hall. Attached to a chain on the stone was a tin cup for convenience. Like the 1920 war memorial, the drinking station was paid for by the public. Most people consider a trough acceptable only for quadrupeds, but sources say this one was built for two-legged mammals, as well—maybe, at least, for them to operate it. The trough was moved to the fire department in Gaylordsville.

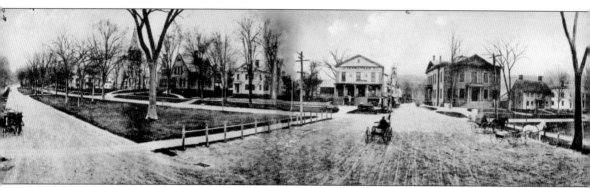

FOUR-POSTCARD PANORAMA. Views of the green and the surrounding area are seen here, looking, from left to right, to the north, east, south, and west. The known buildings on Main Street are, beginning at the left, the First Congregational Church, Col. Nathaniel Taylor home, William Wright home, St. John's Episcopal Church, New Milford Public Library, Col. William J. Starr home, and Staub & Mallett hardware store. The Roger Sherman Town Hall is at the corner of Church and Main Streets, and the next three buildings on Main Street are the Noadiah Mygatt

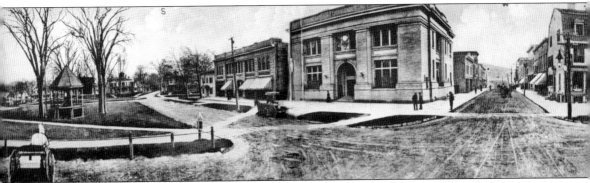

home, John Glover Noble home, and Josiah Lockwood home (blurred). Across the road on Bridge Street can be seen 64 Bridge Street (house built by Charles M. Beach), 62 Bridge Street (double house built by Charles M. Beach), the bandstand, Royal Canfield house, Alanson Canfield house, 50 Bridge Street, unknown, the Allen Building, and the United Bank Building. On Bank Street are numbers 17, 21, 25, and 31 on the south side; numbers 26, 20-24, 16-18, 12-14, and 10 on the north side; and the United States Hotel.

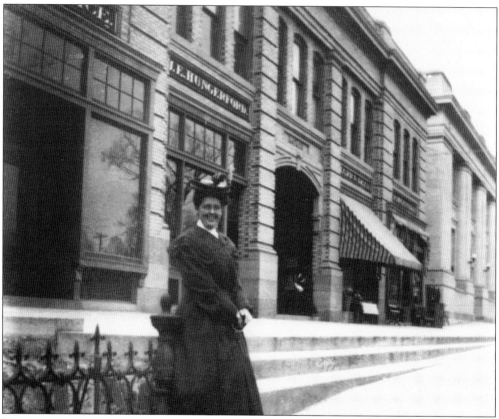

WAITING FOR THE MAIL? The woman in front of the post office has been identified as Flora Geer Stilson, the first curator of the New Milford Historical Society. She poses in front of the steps of the Allen Building, 7-15 Main Street. The post office is now Tivoli Restaurant.

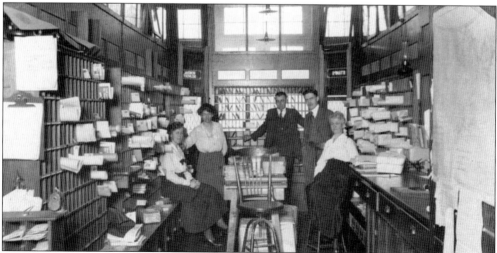

NEW MILFORD POST OFFICE, 1923. Inside the post office is the second curator of the New Milford Historical Society, Mary Elsie Hall (second from right). The others are, from left to right, Angela Murphy, Gerald Northrop, Harold Hunt (assistant postmaster), and Kate Spencer (postmaster). In 1935, the building was occupied by Simpson Studio.

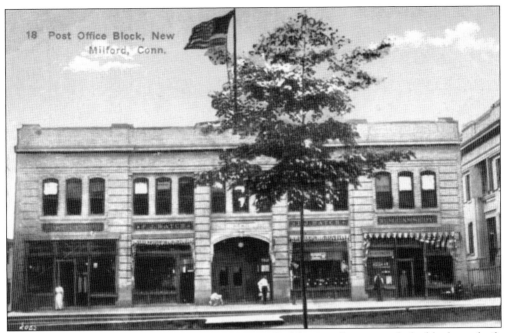

THE ALLEN BUILDING. Referred to as the post office building on the postcard, the block was built shortly after the 1902 fire. Here, the name "Hatch" appears on both sides of the big door in the center, and the enterprise to the right is P.M. Cassedy's.

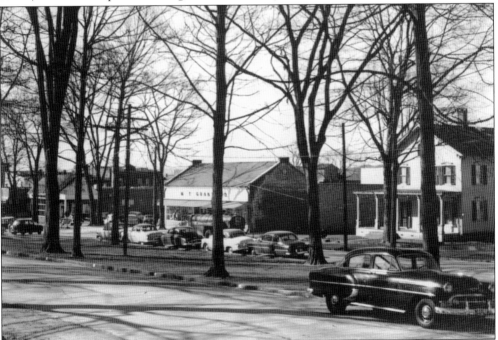

ACROSS THE GREEN, LOOKING SOUTHWEST. On the far left, in the background, is New Milford's current post office. To the right of the parking lot is W.T. Grant's department store, which had previously been on Bank Street. CVS occupied this 41 Main Street site before it moved to East Street at Brookside Avenue. (Photograph by H.I. Hunt.)

CIVIL WAR REENACTORS. These men, seen here marching on the green, were part of the inaugural Underground Railroad Walking Tour, held on September 6, 2003. The event, sponsored by AACAA (Afrikan-American Cultural Awareness Association), entailed a seven-mile trek beginning at the New Milford High School. Stops were made at known stations on the Underground Railroad in New Milford, plus two rest stops at the Quaker Meeting House and Harrybrooke Park. It ended on the green, where several programs were held.

NEW MILFORD OUTDOOR ART FESTIVAL, 2012. The New Milford Historical Society has sponsored this popular event on the village green for several years. The two-day event is usually held in early June, on Father's Day weekend. The festival began in 1996. Artists set up tents to display their work. Prizes are given in the categories of watercolor, oils, pastels, acrylics, photography, and etching.

Ten

THOUGHT I'D STOP BY

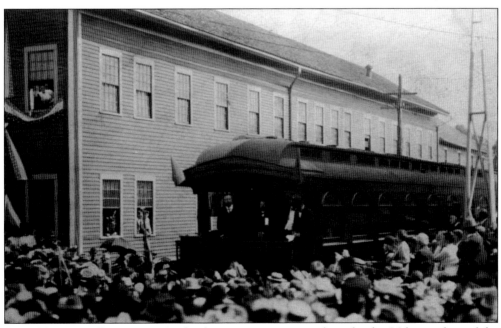

PRES. THEODORE ROOSEVELT. A whistle-stop campaign tour brought the 26th president of the United States to New Milford on September 3, 1902. The last car of the train was positioned to stop at the Bridge Street railroad crossing. Employees of the Green warehouse witness the event at the windows of the building next to the train tracks. Veterans of the Spanish-American War and the Civil War were among the crowd of 2,500.

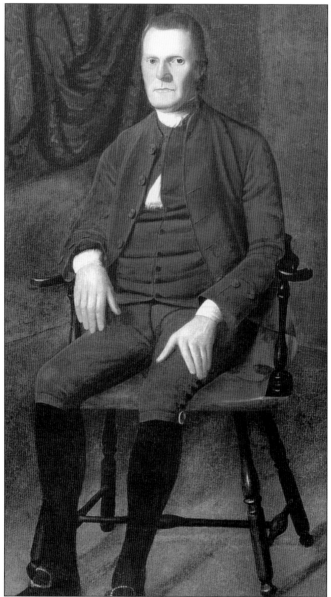

ROGER SHERMAN. Sherman's visit to New Milford lasted 18 years. He arrived in 1743 and removed to New Haven in 1761. It was after he left New Milford that he achieved notoriety for signing those four essential documents of American liberty: Articles of Association (1774), Declaration of Independence (1776), Articles of Confederation (1778), and the Constitution of the United States (1787). Sherman did represent New Milford in the Connecticut Legislature from 1755 to 1761. He was appointed county surveyor and owned more than 1,000 acres in New Milford, making him the largest landowner in Litchfield County. He had a permanent home on Park Lane in New Milford beginning in 1748 and a shoe shop near the village green. In 1897, through the efforts of the New Milford Chapter of the Daughters of the American Revolution, named after him, town hall became the Roger Sherman Memorial Town Hall. In 2013, he was inducted into the seven-year-old Connecticut Hall of Fame with Geno Auriemma, Jim Calhoun, and A.C. Albert. (Portrait by Ralph Earl.)

Washington's Tree near Gaylordsville, New Milford, Conn.

WASHINGTON OAK. Gen. George Washington and the Marquis de Lafayette had a meeting under this tree in Gaylordsville. They were here in the middle of the American Revolution on September 20, 1780. After having lunch with Deacon Benjamin Gaylord, a conference with 22 officers was held under the tree. The group was on its way to Hartford, having left headquarters in New Jersey three days prior. The tree was designated the "Washington Oak" about the time the Roger Sherman Chapter of the Daughters of the American Revolution was appointed its guardian. It was over 300 years old when it split apart in 2003. When workers cleared the mess, they found a family of kittens residing inside the stump. The kittens were rescued, wood was saved to be made into gavels by the Daughters of the American Revolution, and acorns were planted. A sapling and a plaque now exist where the mighty oak once stood.

ADAM SANDLER. "The Sandman" waves to onlookers who had gathered around Bank Street, where his film *Mr. Deeds* was shot in May and June 2001. He was heard yelling from the vehicle, "Where's Adam Sandler?!" The New Milford Film Commission, organized in 1997, helps facilitate the logistics of filming in New Milford, including obtaining production assistants, assisting with permits, and helping with a casting call.

LITTLE RED CORVETTE. "America's Sports Car" was seen en masse in New Milford when 30 'Vettes took over Bank Street. The cavalcade was for the final scene of *Mr. Deeds*. Longfellow Deeds buys everyone in town a Corvette, including Crazy Eyes (Steve Buscemi), who directly drives his car into a tree.

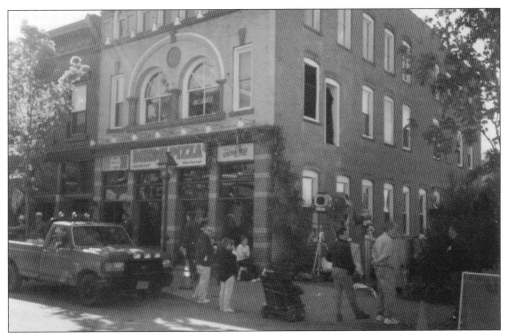

DEEDS' PIZZA. The Bistro Café at 31 Bank Street was transformed into Deeds' Pizza in the summer of 2001. Prior to the shooting, the producers of the movie had lunch at the restaurant, where they decided that New Milford would stand in for Mandrake Falls, New Hampshire. "French fries and Oreos," anyone? "Peanut butter and gumballs?"

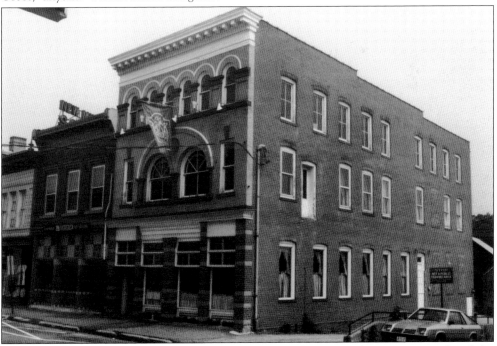

31 BANK STREET, 1984. Built around 1902 as the Lincoln House, this structure replaced the hotel that perished in the great fire. The lodging house began in 1885 and closed in 1925. It was a bank for 10 years; today, it is home to Salsa Restaurant and other businesses.

GOODENOUGH FUNERAL HOME. In 2007, the law offices of Allingham Spillane (now Allingham & Readyoff) became the Goodenough Funeral Home in Tim Allen's *The Six Wives of Henry Lefay*. Scenes were filmed inside and outside the historic home, built in 1840 for Ithamar Canfield. Other scenes were filmed on Bank Street, the village green, and Bridge Street. Mr. Goodenough was portrayed by Edward Herrmann.

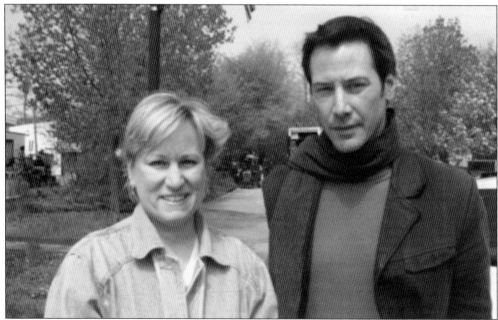

KEANU REEVES. The actor was in town in 2008 for the filming of *The Private Lives of Pippa Lee*. The movie was directed by Rebecca Miller, daughter of Arthur Miller, and the wife of actor Daniel Day-Lewis. Here, Reeves poses near the railroad station with Colleen Carroll of Brookfield.

"Won't Leave Here for a While." An antique leather postcard manifests a sentiment for Connecticut's 47th town. There have been other notables who have visited New Milford. In 2013, Jerry Seinfeld and David Letterman were in town for an episode of *Comedians in Cars Getting Coffee*. Author Edna Ferber spent sufficient time in the Noble House on Danbury Road to gather information for her 1931 book *American Beauty*. Marilyn Monroe stayed at the Homestead Inn when she was married to Arthur Miller. The inn has also hosted pianist Vladimir Horowitz, actor Frederick March, and artists Philip Kappel and Edith Newton, who apparently liked what they saw and made New Milford their home. The same can be said for Peter Gallagher, Skitch and Ruth Henderson, Eartha Kitt, Joan Rivers, Isaac Stern, and Diane von Fürstenberg. New Milford filmmaker Dore Shary produced a movie based on his neighbor's (Eric Hodgins) book, *Mr. Blandings Builds His Dream House*, produced in 1948 and starring Cary Grant and Myrna Loy. "Why have these people chosen New Milford for their homes? They see a village of old New England, where the natives are proud of their family names and loyal to their homes, where neighbors are friendly and town organizations are active, where spirit and enthusiasm abound, and where beauty and serenity dominate. They have found one town with personality," from *Of Interest to New Milford*, 1935.

DISCOVER THOUSANDS OF LOCAL HISTORY BOOKS FEATURING MILLIONS OF VINTAGE IMAGES

Arcadia Publishing, the leading local history publisher in the United States, is committed to making history accessible and meaningful through publishing books that celebrate and preserve the heritage of America's people and places.

Find more books like this at
www.arcadiapublishing.com

Search for your hometown history, your old stomping grounds, and even your favorite sports team.